Papier-Mâché
MONSTERS

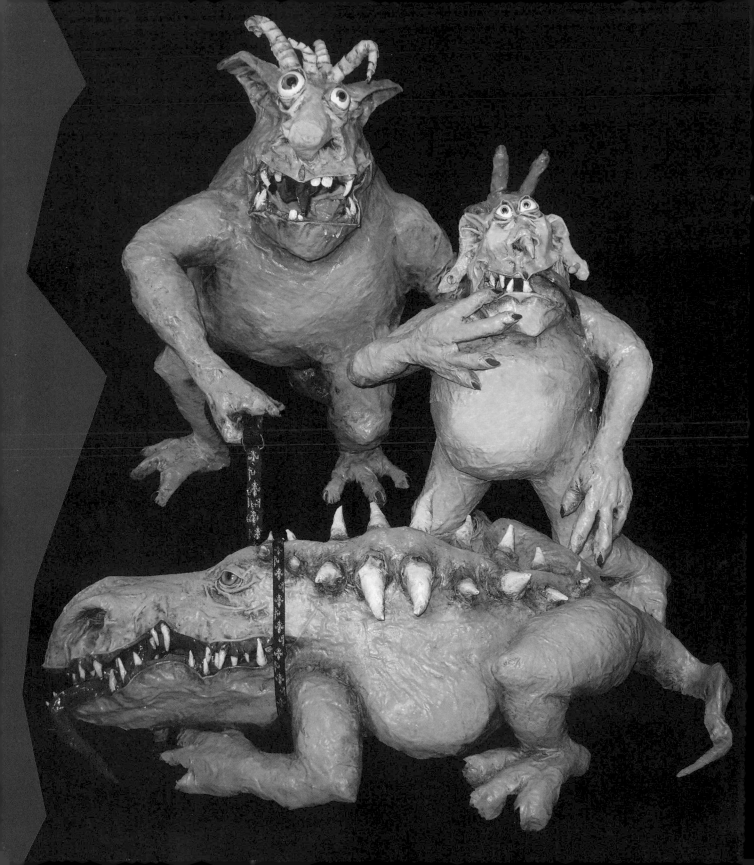

Papier-Mâché
MONSTERS

Turn Trinkets and Trash into Magnificent Monstrosities

DAN REEDER

Photographs by Julie, Jeff, and Dan Reeder

GIBBS SMITH
TO ENRICH AND INSPIRE HUMANKIND
Salt Lake City | Charleston | Santa Fe | Santa Barbara

TO JULIE, ALLISON, AND
ANDREA. THANK YOU FOR
PUTTING UP WITH ME!

WARNING! THE PROJECTS IN THIS BOOK ARE NOT INTENDED FOR CHILDREN
TO DO ON THEIR OWN. CHILDREN SHOULD BE UNDER ADULT SUPERVISION AT
ALL TIMES WHEN ATTEMPTING THESE PROJECTS.

First Edition
13 12 11 10 09 5 4 3 2 1

Published by
Gibbs Smith
P.O. Box 667
Layton, Utah 84041

1.800.835.4993 orders
www.gibbs-smith.com

Designed and produced by Dawn DeVries Sokol
Printed and bound in China
Gibbs Smith books are printed on either recycled, 100% post-consumer waste, FSC-certified papers or
on paper produced from a 100% certified sustainable forest/controlled wood source.

Library of Congress Cataloging-in-Publication Data

Reeder, Dan, 1950-
 Papier-mâché monsters : turn trinkets and trash into magnificent monstrosities / Dan Reeder ;
photographs by Julie, Jeff and Dan Reeder. — 1st ed.
 p. cm.
 ISBN-13: 978-1-4236-0555-3
 ISBN-10: 1-4236-0555-1
 1. Papier-mâché. 2. Monsters in art. I. Title.
 TT871.R435 2009
 745.54'2—dc22

 2009003827

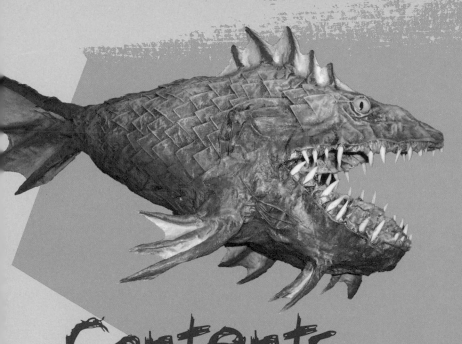

Contents

Introduction

Perhaps the most common question I've gotten about my art over the years is, "Where do you get your ideas?" My usual answer has been, "I dunno."

Now, after years of deep introspection, I've realized that monsters speak to me—literally. In fact, I'm convinced that I channel them. Kinda like the infamous J. Z. Knight, who claims that a warrior who lived thirty-five thousand years ago speaks through her. (From what I gather, her warrior friend tells her to charge people lots of money for his wisdom and then buy thoroughbred horses with it.) My channeling is slightly different. No old geezer trying to take over my body. I just notice some little voices inside my head, usually when I'm quiet, just before I fall asleep. Mostly they say, "Let us out!" although sometimes it's, "Wouldn't a Milky Way candy bar taste great right now?" And I do let the monsters out. You will see some of them in this book. Some of them I've kept tied up, or caged, for your safety and mine.

And I think it's about time you let your inner monster out too. There is no greater thrill in the world[1] than taking a few simple materials, making a big mess, and then watching a monster, or a dragon, or even a fish or piggy, pop out. I'm here to testify that thousands of people who have used my papier- and cloth-mâché methods have had this happen to them, and they have fallen in love with their little beasts. Some have told me that the experience changed their lives forever[2] and that they love their monster even more than their husbands, wives, and children.[3]

The truth is that even after thirty-five years of doing papier-mâché, I'm still in love with the work. And I think everyone should be doing it. It's the perfect 3-D medium for novices and accomplished artists alike. It's supremely forgiving. You can make mistakes and fix them. You can create really fun sculptures without entering the realm of wood or stone, arenas usually reserved for skilled artisans. If you begin your 3-D art experience by making a monster following the instructions in this book, then I guarantee your success. I'll give you tried-and-tested, goof-proof methods.

Now, I realize that some of you may have already bought one or both of my previous books. For the sake of truth in advertising, I need to tell you that the techniques you see in this book are not new. Since I last talked to you, I did explore some other

[1] The absolute truth.
[2] A bit exaggerated.
[3] Totally made up.

papier-mâché methods. But in the end, I decided that I liked my own the best. So you might want to know how this book will be different. Well, this time, I'm going to give away **all** of my secrets. Yes, you heard that right. I'll share with you my vast reservoir of secret papier-mâché knowledge, whether you want it or not. And I'll slip in some information that's not so secret, but useful, as well as some fairly non-profound helpful hints and details that will make your papier-mâché-monster-making-life much easier. Finally, I'll pass along some interesting facts about life that have nothing to do with papier-mâché but might give you something to talk about over dinner. How's that for jam-packed?

For those of you who need such information, perhaps we should begin with a brief . . .

History of Papier-Mâché[4]

Papier-mâché has been around for a very long time. Most papier-mâché historians agree that it started in China around the second century. Or maybe it was India. It seems that waste paper was molded into all kinds of things, including pen holders and jewelry. Amazingly, the Chinese also used it to make

spears and helmets. I would guess that such weapons were used to fight bands of marauding puppets.

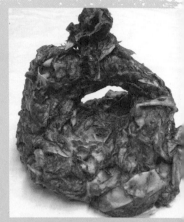
French Papier-Mâché Art

Apparently, papier-mâché wandered into Europe around the sixteenth or seventeenth century. The French coined the term "papier-mâché," which literally means "chewed paper." I guess there is some evidence that people actually chewed the paper, then squished it into stuff called "French art." Around the same period some Germans decided to make furniture out of papier-mâché. It was cheaper than using wood. I've managed to procure a couple authentic papier-mâché artifacts to illustrate such uses.

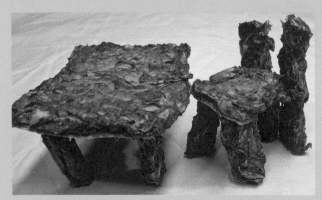
Papier-Mâché Table and Chair

[4] Not necessarily accurate.

Eventually, papier-mâché furniture factories disappeared. No one knows why. And papier-mâché art sort of faded away as well until sometime in the 1950s when a small papier-mâché renaissance began. Somewhere in America, a really cool third-grade teacher (Mrs. Sullivan, I think her name was) decided to have her students make papier-mâché piggies. They took strips of paper, dipped them into flour-and-water paste, and applied them to balloons. Two weeks and thirty identical piggies later, papier-mâché was born anew, although no one seems to know how that process came to be called papier-mâché since there was nothing chewed or French about it. Still, such a process is what most adults remember when papier-mâché is mentioned.

Of course, this is a book about monsters. I'd be remiss if I didn't also give you a brief . . .

History of Monsters[5]

Speaking of the French, the word "gargoyle" is derived from the French word "gargouille," which means "throat." The English words "gargle" and "gurgle" share the same root. Gargoyles were the beasts that "spit" the water that came off buildings when it rained. A "grotesque" is a gargoyle that doesn't spit. Perhaps the most famous gargoyle is the "Spitting Gargoyle" on the Notre Dame Cathedral, although he is actually a grotesque because he doesn't really spit.

One of the definitions of "monster" according to Dictionary.com is "any animal or human grotesquely deviating from the normal shape, behavior, or character." I suppose that if monsters deviate grotesquely, then they must not be spitters.

Folklore suggests that monsters and gargoyles were added to buildings to frighten away evil spirits. This seems a bit strange to me—kind of like taping candy bars to your forehead to protect yourself from sugar.

Considering the French connection between these two historical perspectives, it's pretty clear that . . .

Monsters and Papier-Mâché

. . . are related, hence the need for this book.

How to Use This Book

One thing I've learned over my long life is that many people genuinely think differently than I do. This realization has been very enlightening! I now understand that I must at least acknowledge other viewpoints despite the fact that my opinion is correct almost all of the time. Still, I think that this realization has made me wiser and has helped me to

[5] Think of this history as a kind of Wikipedia entry, with only one contributor . . . me.

become a more socially responsible monster maker. In this section I've decided to tailor my remarks to the various learning and thinking and living styles of people I have encountered. This may appear to some as blatant stereotyping. Rather, try to think of it as an innocent attempt to meet the needs of all the crazy people on this big planet.

So please, find the phrase that best describes you and read that section.

1) You are not too literate but are fun loving.

I know that you couldn't care less about all the words in this book. You just want to get to work. Good for you. Just look at the pictures and go! I've attempted to create a very complete photo chronology (pictures in order) for monster making. Start on page one. Look at each picture. Thank you for reading this far!

2) You are literate but lazy.

I know you like words. They give you inspiration, even if they don't necessarily compel you to actually do anything. For you, I've added some completely useless commentary along with my simple, goof-proof instructions for monster making. Make sure that you read this book very carefully and think deeply about each instruction before you decide to begin making your monster. And please know that even if you don't end up making a monster, you will undoubtedly grow as an artist and a person by reading this book.

3) You are highly intellectual and critical.

I realize that not only do you like the written word, but also you are intellectually gifted and probably could have written a much better monster-making book than this one. I understand that you like to dive deeply into the history and philosophical significance of any topic you are reading about. For you, I've made a concerted effort to add some intellectually meaty information, some robust papier-mâché philosophy,[6] as well as some hard papier-mâché science.[7] I fully expect that you might vehemently disagree with my art methods and what I have to say. Feel free to write to somebody and complain. Meanwhile, get your lawyer and start testing my claim that my methods are "goof proof."

4) You are fun-loving, kind, forgiving, and you like world peace.

First let me say that I love you dearly. I truly appreciate that

[6] Make sure you argue about this with your snooty friends.
[7] I'm preparing to submit this information to JAMMA (The Journal of the American Monster-Making Association).

you understand where I'm coming from and that my heart is pure even if my humor seems a little quirky. **You will see a number of cats throughout this book.** Please know that none of them were harmed in the making of this book. (I didn't really make Eddy eat only hard food for a week. Actually, he only likes that expensive soft food that comes in the little dark green cans that say "Exquisite Taste" on them.) Make sure as you embark on this monster-making journey that you treat yourself with kindness and respect as you work the steps. Make sure when you make your flour paste that you add water that is between 82 and 85 degrees. Considering the significant work you've done on behalf of the planet today, you deserve only warm water in your paste. Work at your own ergonomically correct pace. Know that all my monsters are really smiling, in their hearts. Well, they would be if they had hearts.

5) You are fairly normal (at least on the outside), smart (but not too smart for your own good), and hard working.

Look at the basic steps for making a monster. Don't have too much of a preconceived idea of how it should turn out. Be loose. Let the piece evolve as you work. Know that the very things that seem like mistakes early on in the process will become part of the charm and personality of the finished monster. The basic little green monster profiled in the main part of the book grew in just such a fashion. As I was making it for the book, I simply let it become the monster it was supposed to be. Of course, if it hadn't, I could have cut it up and used the parts for a monster I did like. That's what I mean by papier-mâché being a "forgiving" medium.

6) You are "special."

Don't make a horse on your first attempt. It's really hard to get the legs right.

What You Need to Know Before You Begin

When most people think of papier-mâché, they think of applying strips of paper over a balloon. On a larger scale, they think of molding a shape out of chicken wire and then applying a "skin" of papier-mâché. If you think about it, this is sculpting with balloons and chicken wire. As you will see, I make papier-mâché balls and limbs, cut them up, and assemble a monster out of the pieces using masking tape. I truly sculpt with papier-mâché. Then I apply a skin of torn-up bedsheets dipped in Elmer's glue. I suppose that this is my claim to fame, this use of cloth in combination with papier-mâché. I coined the phrase "cloth-mâché" when I first started doing this thirty-five years ago, even though there was no more chewing with the cloth than there was with the paper. This cloth-and-glue coating gives amazing strength to papier-mâché art and offers endless possibility for detail. A few well-placed wrinkles, scales, lips, and eyelids, and your monster will come alive!

While the process is pretty straightforward, there are a few tips I will share in advance that will make your monster making easier and more efficient.

About Paper Strips
When you made papier-mâché in elementary school, my guess is that you used thin strips of paper. Let's put an **end** to that practice right now. In fact, if you've ever considered being politically active and are looking for a good cause, this is it. Or maybe consider a tattoo with the words "No Thin Strips" written across a broken heart on your chest (listen, I've seen worse).

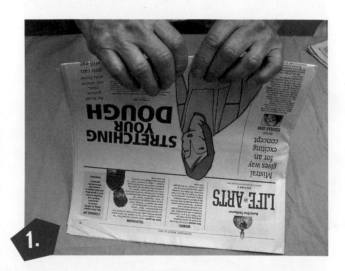

1.

We want **w i d e** strips. Take sections of newspaper and tear them down the middle, starting on the folded side.

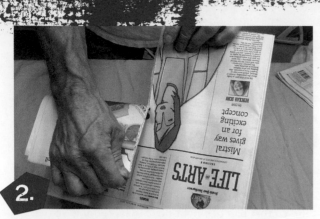

2.

Also tear off the folded end. Newspaper has a "grain" and will tear surprisingly straight.

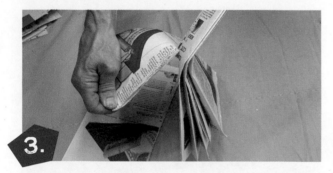

3.

Turn the section on edge to easily find the middle fold and tear it.

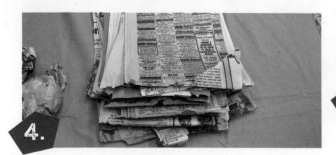

4.

A perfect stack of wide paper strips.

About Cloth Strips

As far as cloth-mâché is concerned, the best cloth to use is an old bedsheet. In fact, the older and more thread-bare the sheet, the easier it will be to use. You can use any kind of cloth, but newer, stiffer cloth will tend to lift up at the edges or unfold when you make scales or eyelids. Since most people in the world sleep on cloth sheets, you shouldn't have much trouble finding one for your monster. Ask around or get one at a secondhand store. If you are a kid, just go ahead and use your own sheet. I'm sure your mom won't mind. If she gets mad, remind her that you are "gifted."

Once you've put your hands in the glue, the last thing you want to do is to stop and cut cloth. It's best to create a pile of various-sized cloth strips and pieces beforehand.

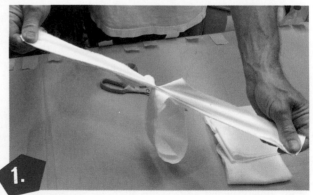

1.

Start by tearing the edges off your sheet (you might need to use scissors to start the tears). Then tear the sheet into strips of various widths.

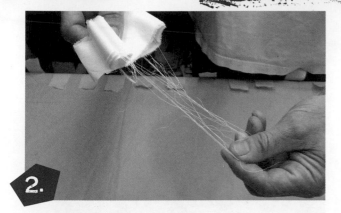

2.

Fold the strips in half, then in half again, and maybe in half again after that (depending upon how long your strip of cloth is to begin with). Of course you can only fold eight times at the most, although that would certainly be overdoing it. (You did know that it is impossible to fold **anything** nine times, right? It's true. Proven beyond a doubt mathematically. Look it up!) Grab the strings on each side and pull them off.

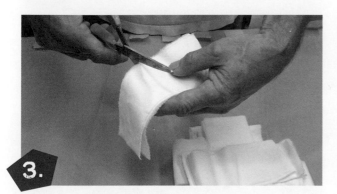

3.

Cut the folded strips into various-sized pieces of cloth. One last note: If you tear the strips in this manner, two sides of these pieces of cloth will be a little frayed. Frayed is good. Frayed edges are less likely to show as

seams after they have been dipped in glue and painted. Just a thought for those of you who lose sleep because of pesky monster cloth seams.

About Tape and Glue

As I said, I sculpt with papier-mâché pieces held together with masking tape. I love masking tape. I love the way it holds stuff together. I love how strong it is under my cloth and glue skin. I would marry masking tape if it were a woman and if my wife didn't mind.

I like white glue too. But not enough to marry it. I use Elmer's glue. You can use a generic version of white glue as well. You will need a couple of quarts for an average sized monster. As is many times the case, you can buy a gallon at a large hardware store for less than a couple of quarts at a hobby store.

If you look carefully at the photos of me assembling my monster, you'll notice that I have pieces of tape stuck all over the place. If you tear a lot of tape strips first and keep them within arm's reach, sculpting will be

much easier. This is particularly true if you are holding two parts tightly together and you need several pieces of tape quickly.

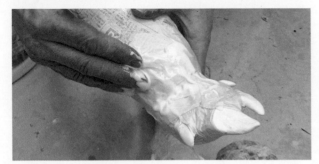

Even though masking tape is the most wonderful product on the planet, sometimes it loosens a bit if you store your unfinished project in a warm place for a long period of time. If you need to leave your monster (or pig's foot) unfinished for a few days, wipe it down with Elmer's glue. This will hold the tape tightly in place.

About Recycling

I would never presume to take credit for reducing global warming or for cleaning landfills or reducing our dependence on foreign oil. But I've taken a pretty big stack of newspaper over the years and recycled it into monsters. And I take some credit for reducing our dependence upon foreign monster making.

While I'm on the topic of recycling newspaper, I want to make sure that you know how to recycle your recycled newspaper. Look for opportunities to reuse the wads of crumpled newspaper inside the papier-mâché

balls that you cut up. Usually the crumpled balls inside will pop out perfectly shaped to re-mâché. Just wrap some masking tape around the wad and put it aside for your next project. With some of my larger art pieces, I've repeated this process nine or ten times with the ball getting a bit smaller each time![1]

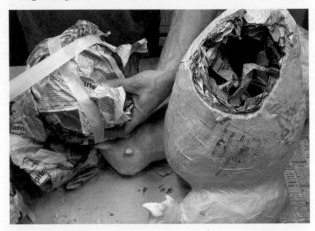

Piggy's belly provides another precious monster body.

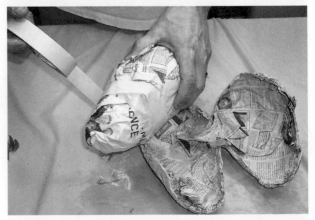

This head begets another head.

[1] Plus or minus eight.

About Wire Clothes Hangers and Big Projects

I've made some pretty large papier-mâché art over the years. In fact, I don't know any other medium so well suited for big art. That said, the larger the project, the more "infrastructure" is needed. For this I use wire clothes hangers. In fact, you will soon notice that I use wire clothes hangers in virtually all of my art projects. So a note about them is in order. There was a time when these were omnipresent. Unfortunately, like everything else in modern society, wire clothes hangers gave way to plastic ones. (Remember when cars were made of metal? Toothbrushes?) Luckily, wire clothes hangers are still used in dry cleaning. And over the years, at least a zillion were produced and are still floating around out there for you to find. You don't need that many to make a monster. Six will do. You'll need more if you intend to make something big. Again, ask around. Many people still have them in their closets. You can always find them at thrift stores for a very cheap price. And you can easily buy them on eBay and other places. If you get totally stuck, contact me and I'll send you some.

Back to big projects. I simply put two or even three hangers together as I make arms and legs and tails and other appendages that need to hold weight.

For basic big torsos, I depend upon hangers surrounding the crumpled body balls. Stretch hangers into big circles. Put two together as shown, one rotated 90 degrees from the other.

Stuff a crumpled ball into the hangers and wrap with tape. You can cut off the excess wire later, but

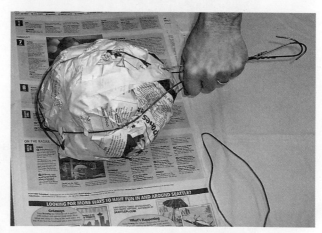

sometimes it's useful to use that wire to connect to other balls. Meanwhile, use the hooks to hang the balls for drying after you mâché.

Tyrannosaurus eatalotacus (next page) is over five feet tall. I built it by connecting many balls with wire around them. You can see the balls if you look carefully at the stomach. I added paper and tape between the balls to smooth the surface. I also doubled up on the hangers I

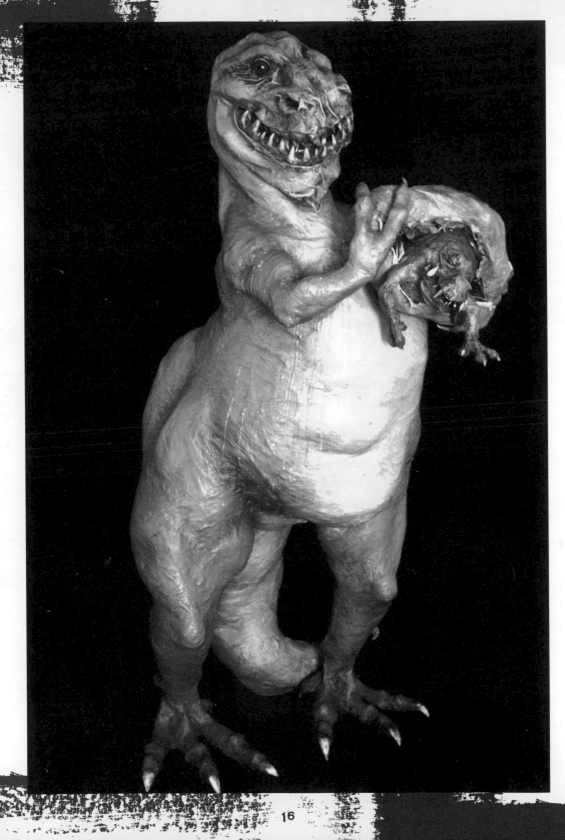

used in the legs, arms, and tail. Between the use of cloth and glue on the outside and the additional wire hangers on the inside, the amount of weight that can be supported is amazing. So go ahead and make something big. I dare you to make it bigger than yourself.

About Personality

Some of my art is very deliberate. I want something a certain way and I work like a dog to make it so. But almost everything in this book was made with the "go with the flow" philosophy that I've been espousing. Particularly if this is your first papier-mâché experience, you should make body pieces that look like the pictures in the book and then just sit back and watch your monster evolve. Try this little personality experiment. I chronicled my possible choices for the eyes on my marionette (see photos, right). Watch the personality change as I change eyes and position. One of them simply felt right. My advice? Play with all of your body parts until everything feels just right.

About Safety

Has your mom ever told you not to run with scissors? I'll bet you didn't listen to her. You just figured that adults worry too much. So don't think of me as just another paranoid adult when I tell you to be careful using the

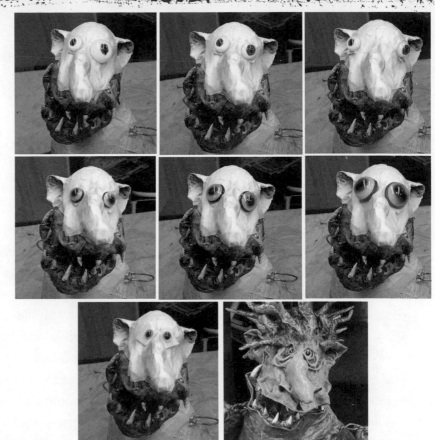

tools of this art form. Think of me as your own personal accident-prone monster-maker trainer. I say "accident-prone" because I've injured myself on every tool I'm telling you to use. Even if you use a dull but serrated knife to cut your papier-mâché balls, it is still a knife, and you should take care with it (duhhh!). Cut with the blade moving away from you. Use the *serrations* to cut, not massive pressure on the blade. And, if you are a kid, get a parent or older sister (not on older brother—he will cut himself) to do your cutting for you. Use the "low melt" setting on your hot glue gun. And don't even think about running with the scissors!

Basic Projects

THIS SECTION IS THE HEART of the book. It describes in detail how to make five different kinds of papier- and cloth-mâché projects. I've tried to give you some variety. The Basic Monster will work for any potential monster maker. The Monster Marionette is a variation of the Basic Monster for those of you who feel that art should be functional as well as pretty. The Monster Trophy is perfect if you want something amazing over the mantel. If monsters aren't your thing (maybe this book was a gift—someone gave it to you because you are a little "quirky" and "artistic"), and you want something a little more traditional, go for the Monster Traditional Piggy. If you are one of those mischievous young boys who love to bug Little Sister (but you don't want to put forth too much effort), the Monster Ugly Doll project is for you. I've also added a "Special Halloween Section" (p. 133) for those of you who want art pieces for that particular season.

So pick one of these projects and launch yourself into the world of papier-mâché. If you are new to this art form, think of your first project as a means to learn the fundamentals. Don't get overly ambitious on your first attempt with any new art medium. Make the project as the book instructs. Trust me—your monster will naturally develop a personality and flavor that is distinctly its own even if you attempt to copy the exact monster I've illustrated. You will be wonderfully successful. Note that I'm not saying the task will be easy. Doing this art requires some hard work and tenacity. Remember, great art is always worth great effort.

Making your first monster is rather like buying the "stripped down" version of a new car. It's going to be really great. You are going to love and cherish your finished piece. But as your proficiency with the art medium increases, you will start seeing additional possibilities. You are going to want some monster "bells and whistles." Or maybe you are an accomplished artist already and you feel totally comfortable attempting a more elaborate project right out of the chute. Take a look at the "Delightful Monster Details" section of the book. A few simple embellishments will move your great monster into the realm of great monster squared. Once you've had a bit of practice with paper and cloth-mâché, look closely at the photos in "More Monsters." You'll begin to recognize the various techniques I've described and, hopefully, become inspired to try a second monster, one that is really you. Of course, once you have two monsters around the house, you might as well go ahead and fill the entire house with monsters. Welcome to my world.

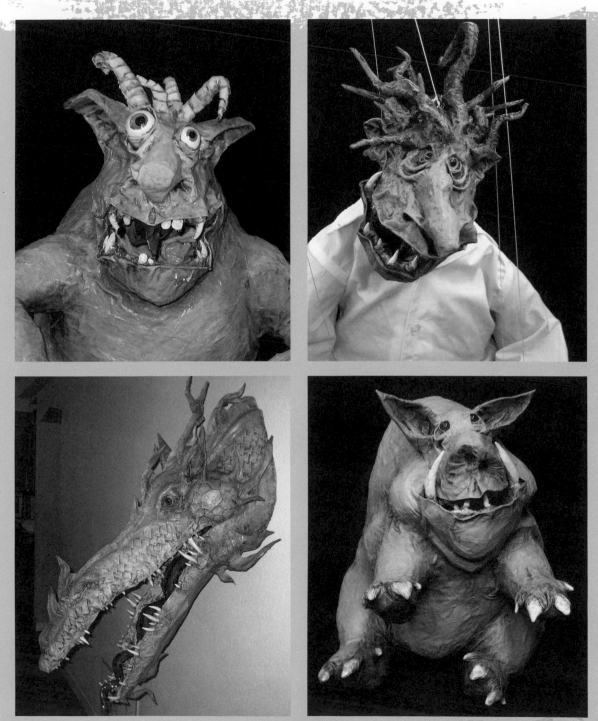

(Note: The Monster Ugly Doll is too ugly to include on this page.)

Basic Monster

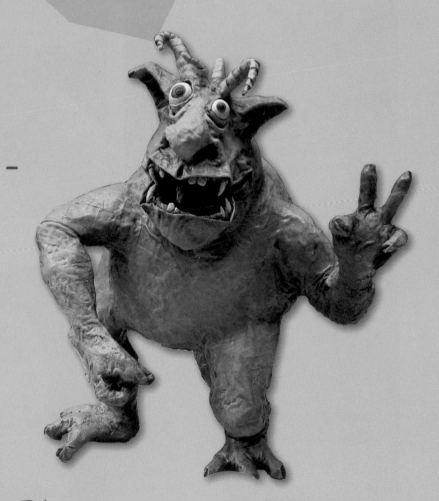

For those of you ready to jump into the monster-making world, here is a complete list of supplies you will need for your monster.

Supplies

- 8-inch stack of newspaper
- 1 roll wide masking tape
- 1 roll thin masking tape
- Wire clothes hangers
- White flour
- Oven bake clay, such as Fimo or Sculpey
- 1 bedsheet (as old and worn as you can get)
- 2 quarts white glue (safe, hobby type)
- Latex paint in primary colors, black, and white
- Anything round for the eyes, such as marbles or clay balls (for especially great eyes, use taxidermy eyes. Just look online under Taxidermists.)

Tools

- Serrated knife
- Scissors
- Wire cutters
- Bowls for paste and glue
- Baking sheet
- Hot glue gun
- Wide paintbrush
- Thin paintbrush

CRUMPLING

For this section you will need:

- Newspaper
- 1-inch-wide masking tape
- Wire clothes hangers
- Wire cutters
- To relax

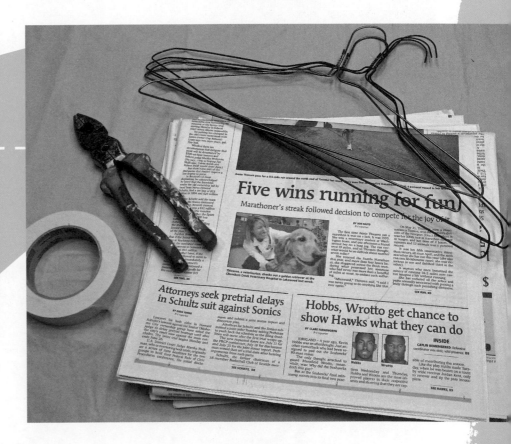

Remember, this is supposed to be simple. Let's keep it that way. You are going to crumple newspaper until it is "body" sized and "head" sized. For many of you, this will seem too vague. Some of you might already be worried about how your first monster will turn out. Listen to me: Let it go. Let it flow. Everything will turn out as it should. You are going to love this!

1. Get Max off the newspaper! (More about cats and papier-mâché throughout the book. Much more.)

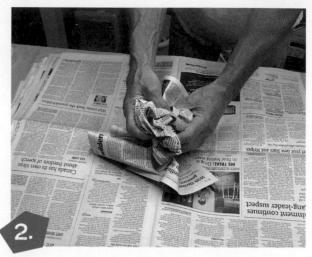

2. Unfold a stack of newspaper. Crumple one sheet into a ball.

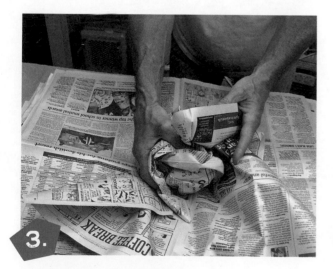

3. Continue crumpling one sheet over the other until you get a ball that is "body" sized.[1]

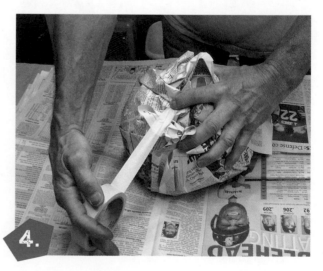

4. Wrap with tape.[2]

[1] If this is too vague for you, then crumple exactly 8 sheets of newspaper, which will match the monster I'm making.

[2] Exactly 6 feet. If you are rich and your manservant is actually making the monster for you, tell him to use the entire roll, just for fun.

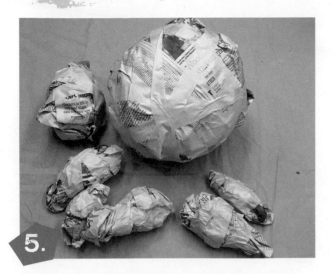

5. Use the same procedure to make a smaller "head" ball. Then make a few smaller balls to use for details: ears, nose, cheeks (both kinds), etc.

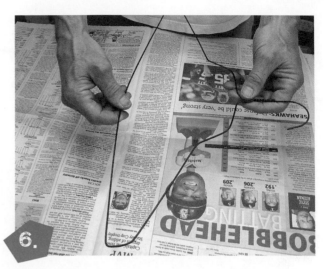

6. For arms, legs, and tails, we will use clothes hangers.

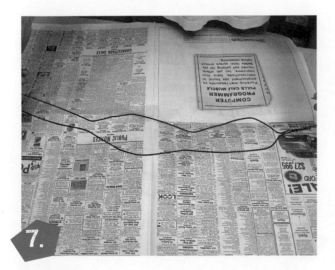

7. Bend the hangers as shown. The bows in the hangers will hold the bicep and forearm of an arm, or the calf and thigh of a leg.

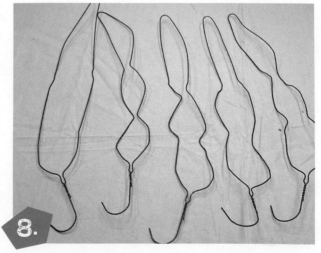

8. Bend a hanger for each leg and arm, and one for a tail if you want one. The tail is just pulled into a point. (A tail is a great idea if you want your monster to stand.)

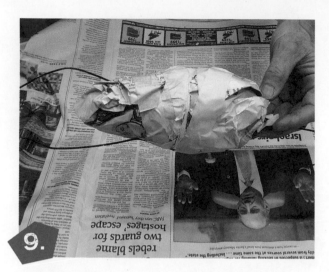

9.

Crumple a "thigh" sized ball to put into the top part of the hanger and wrap with tape.

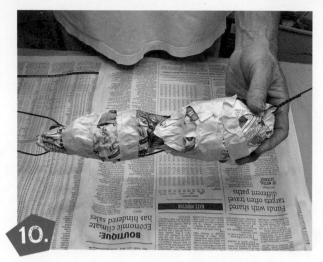

10.

Similarly, stuff a "calf" sized ball into the lower half of the hanger and tape. An arm looks exactly like a leg (maybe a bit smaller), except that the top crumple is the bicep and the bottom crumple is the forearm.

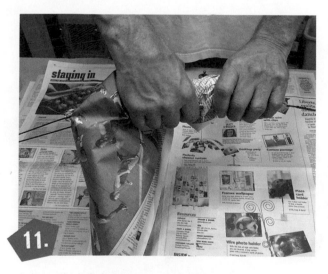

11.

For a tail, tightly twist a couple sheets around the top of part of a hanger.

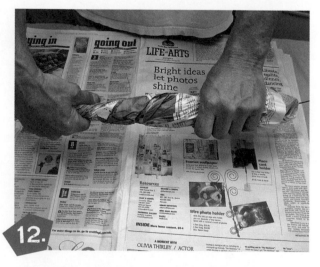

12.

Add another sheet of paper midway down the tail, twisting tightly as you go. Snip off the end of the hanger so that you can twist the end into a point.

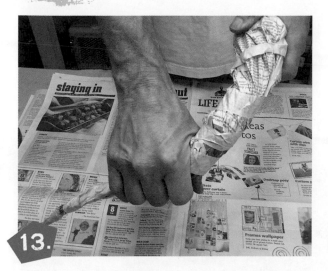

13. To add some movement to the tail, bend the tail in the middle.

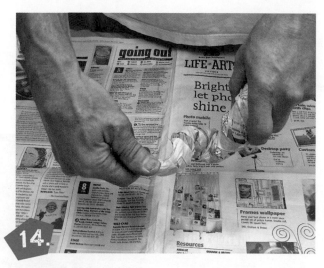

14. Add waves or a curl.

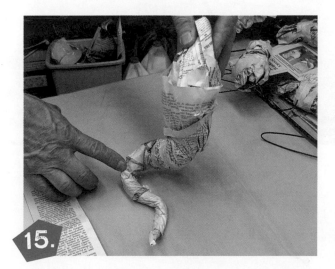

15. Since my monster will stand up, I'll bend the tail so that the end will lay flat on the table.

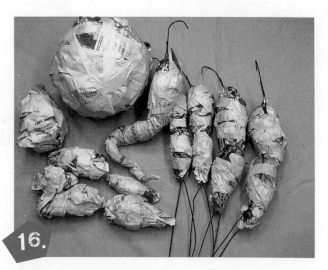

16. Now you are ready to papier-mâché. You should have a body, a head, two arms, two legs, a tail, and several extra balls to use for sculpting.

PAPIER-MÂCHÉ

For this section you will need:

- Cheap white flour
- Stack of wide newspaper strips
- Your body parts
- A mixing bowl
- A childlike attitude

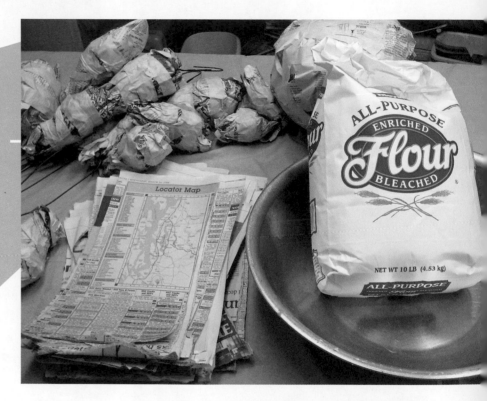

DO NOT buy premixed papier-mâché paste, no matter how it's advertised. Plain inexpensive white flour—the kind with all the nutrients removed and then added back—is what you want. One might argue that we shouldn't take grain out of the food chain, but making monster art with it is certainly better than making gasoline,

don't you think?

This is the place in the book to let your inner kid out. (Unless of course you are a kid, in which case you don't want to let your kid out, because then there would be nothing left of you.) Enjoy making a gigantic mess. Revel in the spirit of all the crazy artists who have come before you. Don't shave or brush

your hair for a week before starting this. Quit your job and just let go.

I am going to sound like a papier-mâché tyrant here. I'm going to tell you **exactly** what to do. And I want you to follow my instructions to the letter. Believe me—it's for your own good. If you want to be creative, do it when you're adding appendages.

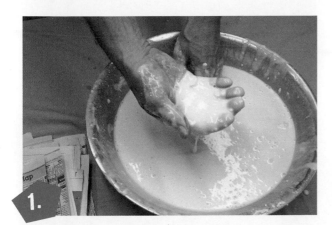

1.

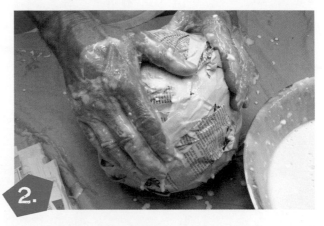

2.

Pour flour into the bowl and add water. Mix with your hands. Continue to add water until you get the consistency of thick soup. In other words, don't worry too much about the ratio. It will work just fine. Use warm water just because it feels soooo nice.

Q: Can I stick my paper strips into the paste?
A: Only if you never mention my name or this book, ever.

This might be the **most important instruction ever given to you.** More than not talking to strangers? More than not drinking and driving? More than not chasing after cars (if you are a dog)? More important than not touching that tractor after the workers went home? Yep, more important.

Wet your hands and rub paste onto the ball. **PUT ONLY YOUR HANDS INTO THE PASTE! Hands only. Only hands. NOT THE PAPER!** There will be a test on this later.

For those of you who want reasons with your rules, this one is simple. Your wet hands will soak each paper strip and ensure that it binds completely to the one underneath it. As you smooth the ball with your hands, the air bubbles will be pushed out. You'll be amazed by how hard the ball will be when it's dry.

When you put strips of paper into the paste, the paste gets spread unevenly. Air bubbles form. Globs of paste don't dry. The ball doesn't get hard, and it begins to stink. Your mom tells you to throw it away. You won't. It comes down to it or you. You decide to run away from home and join the circus. It's bad.

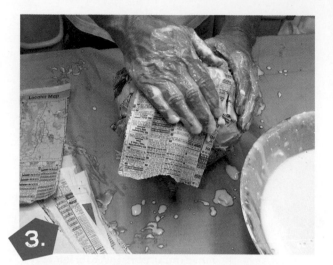

3. Put **one** piece of paper on the ball at a time, smoothing and soaking each piece with your hands. Make sure that each strip of paper is completely soaked before adding a new strip.

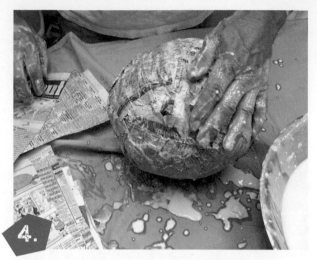

4. Work your way around the ball until you've added three or four layers.

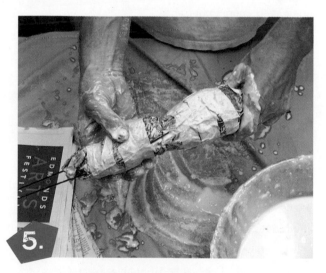

5. Use pretty much the same procedure on the arms and legs. Use your hands to wet the entire leg.

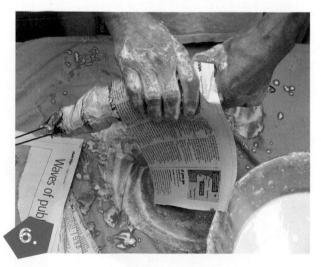

6. Wrap a paper strip around the top, thoroughly wetting the paper as you wrap. Keep your hands really wet.

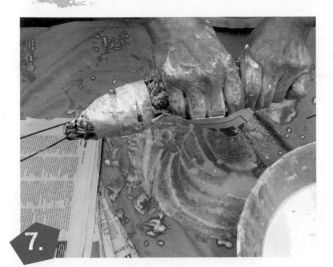

7. Work your way down the leg . . .

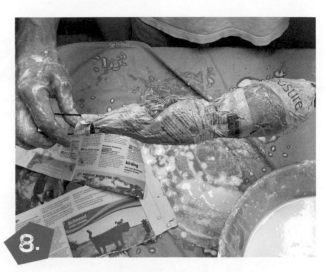

8. . . . squeezing out the bubbles.

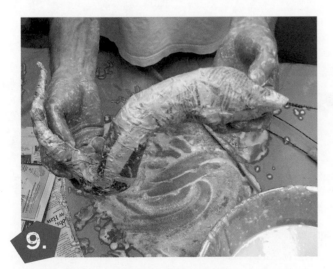

9. Do the same with the tail, working top to bottom. Put the parts someplace warm to dry. I like places around heating vents. Hang the arms and legs and tails by the wire hooks. Turn the balls over after a day or so, so that they dry evenly on all sides.

Q: I'm sixteen and my mom won't let me make a monster till my homework is done. What should I do?
A: Remember, adults in general, and your parents specifically, are out to get you. They are always trying to keep you down. So tell her, "You have enough trouble controlling Dad . . . so quit trying to control me!" Then, make your monster while you are grounded.

FINGERS, TOES, TONGUE, HORNS

For this section you will need:

- Some more wire clothes hangers
- Wire cutters
- Tape (any size will do)
- Newspaper strips or, better yet, an old phone book
- Arms like Popeye (not really, but that's what you'll have after you make enough of these things)

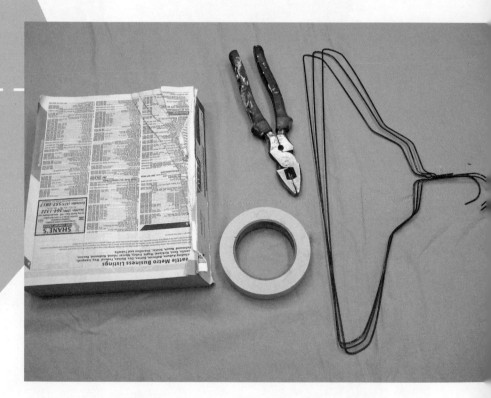

Making these appendages isn't particularly creative. Making them in advance, however, will make the monster-building process much more efficient and fun. We will essentially wrap paper around pieces of wire clothes hanger. Having wire inside the paper allows you to bend the fingers and toes into the shapes you want.

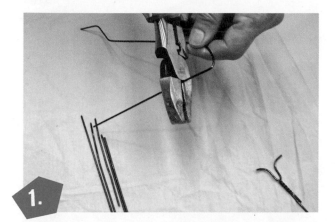

1. Cut lengths of hangers that are a bit longer than the fingers and toes you intend to make. It would be wise to remember that for monsters, and cartoon characters, four fingers look more like five than five fingers.

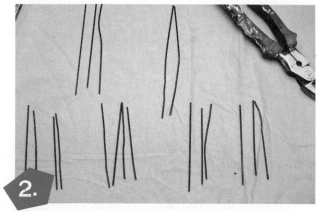

2. Here we have wire for (bottom row) four fingers, another four fingers, three toes, three toes, and (top row) three horns and two parts of a tongue. Note: Consider a few extras, just in case.

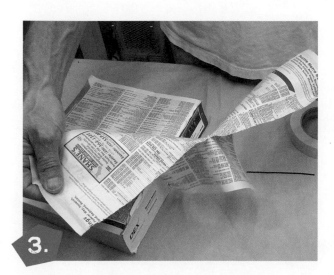

3. Tear off half a piece of telephone-book paper.

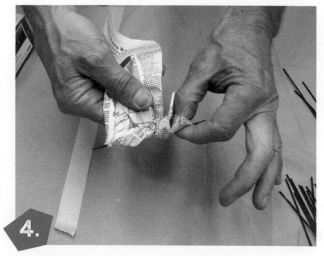

4. Pinch one end of the paper strip with the end of a piece of hanger. Twist the paper around the wire, rotating it over the top of the wire (like the throttle on your motorcycle, for you Hells Angels out there).

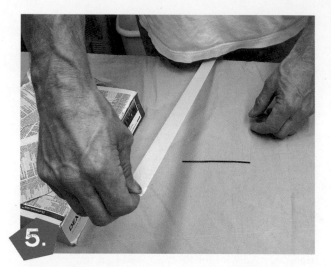

5. Here's another trick. Put the roll of tape between your legs and pull out a length of tape with the sticky side down.

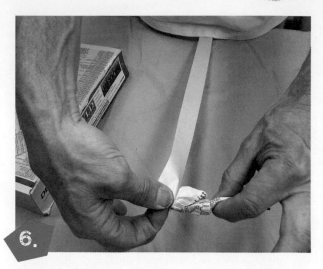

6. Pinch the end of the tape and the end of the finger.

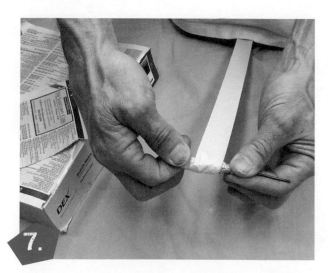

7. Turn the finger with the same motorcycle rotation, keeping the tape taut. Twist the paper tighter, tapering it to a point before you get to the end of the wire. This process will make the fingers and toes tight.

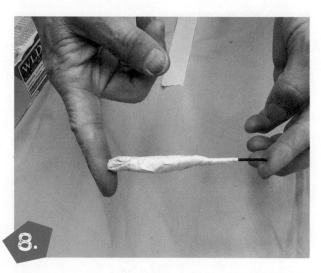

8. Tear the tape. Note that one end is round and could be used for either a finger or toe, and the other end is pointed and could be used as a horn or tentacle.

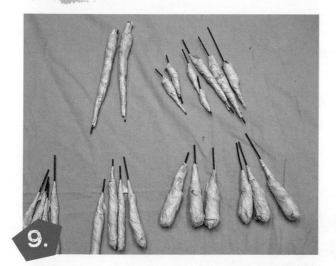

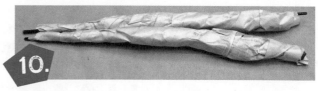

For a cool pointed tongue, put two tapered pieces together like this.

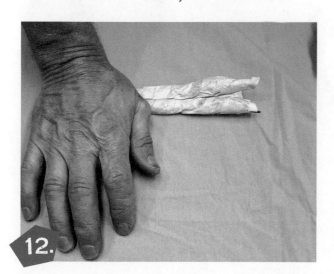

Pictured here are (bottom row) four fingers, four more fingers, three toes, three more toes, and (top row) two parts of a tongue and a bunch of horns (I added a few since we talked last . . . I *told* you to make extras).

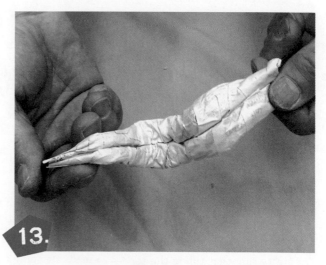

Put one strip of tape across the two pieces. This will be the bottom of the tongue.

Turn it over and squish it so that the tongue is some-what flat.

Add some bends. By only taping one side, you get a nice tongue-like crease.

ARMS & LEGS & HANDS & FEET

For this section you will need:

- More newspaper
- 1-inch-wide masking tape
- Wire cutters
- Your arms and legs
- Your fingers and toes
- A good night's sleep

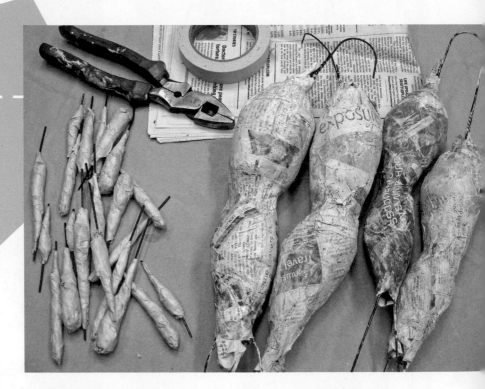

Up until this point you have been making only parts of a monster. Not exactly a thrill a minute. I'm pretty sure that tilling the soil, watering, weeding, and planting can be pretty unrewarding for a gardener as well. But this is all going to change right now. Your seeds are going to start to sprout. Parts of your monster are going to start to take shape. Your heart is going to flutter. (Of course if that continues, you might want to see a doctor.)

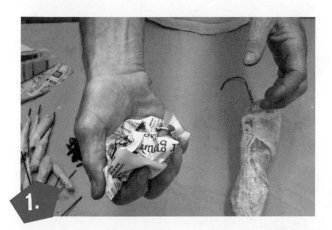

Crumple a sheet of newspaper into a "hand" sized ball.

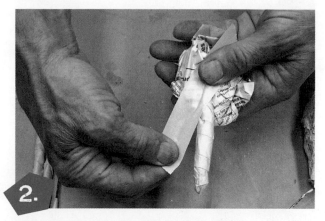

Put a finger in the middle of the crumpled wad. Attach by adding pieces of tape on both sides, in crisscross fashion.

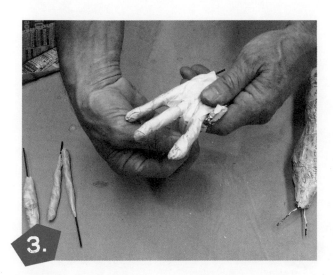

Similarly, add fingers on either side of the first finger.

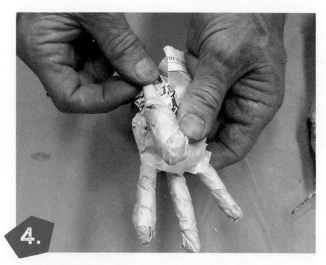

For a bit more realism, put the "thumb" on the other side of the crumpled wad of paper and tape.

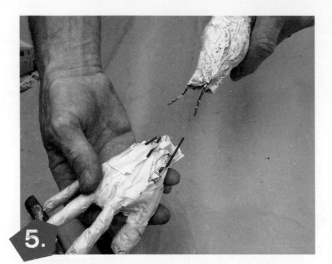

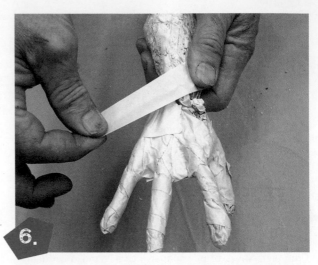

Cut off the end of the clothes hanger on the arm but leave a little of the wire to push into the hand. The small pieces of excess wire make for an excellent wrist—strong yet flexible.

Push the wire ends of the arm into the hand. Tape the wrist by stretching the tape diagonally from the arm to the hand.

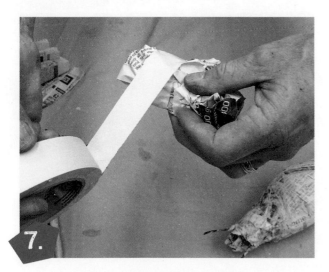

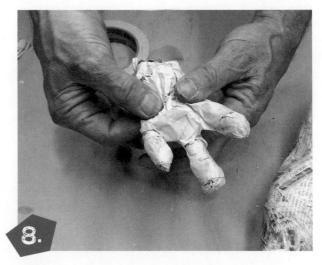

There are only a few differences between making a hand and a foot. For a foot, start with a larger wad of paper than you used for the hand. I like to crumple feet into a more elongated shape.

Add toes the same way you added fingers. I prefer three-toed monsters, but you may want to make a strange looking four- or five-toed monster. Turn the foot over and compress the wad of paper to make an arch for the foot. Add tape.

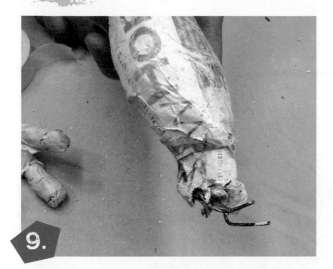

9.

When connecting the leg to the foot, use pliers to bend the excess wire into a 90-degree angle.

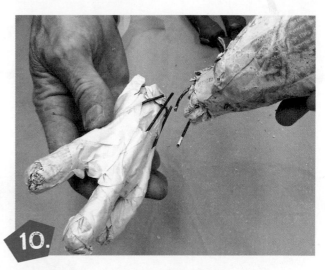

10.

Push these bent pieces of wire into the top of the foot so that the foot comes off the leg at a 90-degree angle.

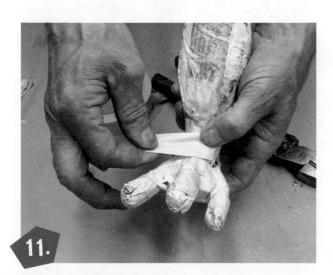

11.

Again, stretch tape diagonally from the leg to the foot and vice versa until the foot is securely attached.

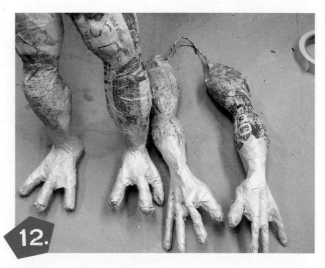

12.

The finished arms and legs. For foot and hand embellishments, see "Gnarly Monster Hands & Feet" (p. 111).

JAWS & CLAWS

For this section you will need:

- Teeth material[1]
- The papier-mâché ball you made for the head
- Hot glue
- A serrated knife[2]
- The good sense your mother gave you

Here are the basic instructions for making your monster's jaws. You might want to check out "More About Jaws and Tongues" in the "Delightful Monster Detail" section of the book before starting your jaws.

[1] I recommend an oven baked polymer material like Fimo (shown here) or Super Sculpey. For more about this, check out "More About Jaws and Tongues" (p. 119).

[2] You don't need a sharp knife to cut up papier-mâché balls. In fact, it's probably better to have a fairly dull knife (less chance for an accident). It is important to have a knife that is *serrated*. Those little saw-like teeth will cut the papier-mâché beautifully. An old steak knife works great. Kids—remember to have an adult do the cutting for you.

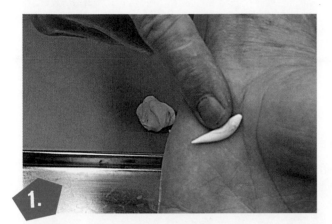

1.

To make a tooth, roll a small piece of clay in your palm or between your fingers until you get a point.

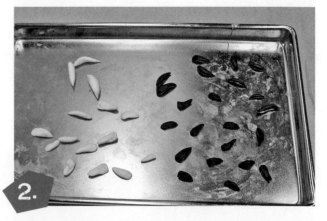

2.

Make as many teeth as you want. Interestingly, teeth and claws pretty much have the same shape. Make claws of various sizes. I chose to use black Fimo for these claws, but color really doesn't matter. Bake the clay according to the package directions.

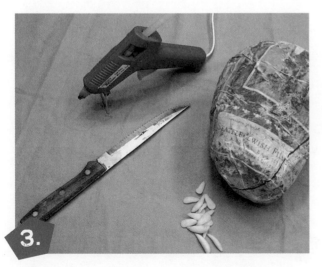

3.

Get your glue gun, knife, and papier-mâché ball.

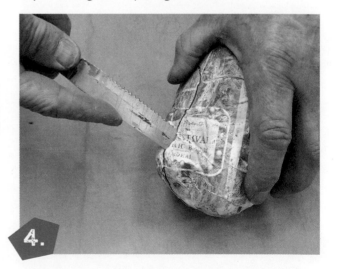

4.

If it helps you, draw a line around the ball to use as a guide for cutting the ball in half. Cut the ball all the way around. I prefer wavy cuts to straight cuts.

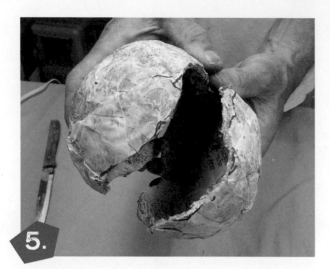

5. Tear the ball apart and take out the wad of paper inside. Play around with the two halves until you recognize the mouth you want.

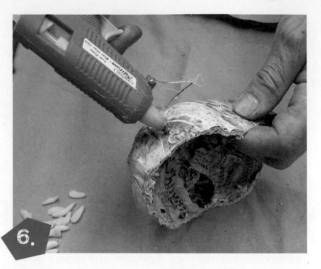

6. Put a dab of hot glue on the shell.

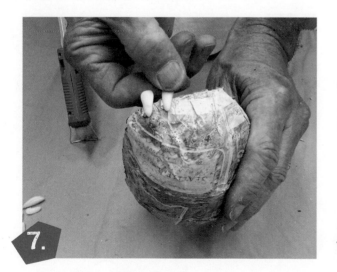

7. Attach a tooth or two.

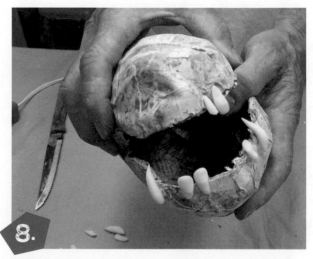

8. I like to have gaps between my monsters' teeth. And I try to put teeth on one jaw opposite a gap on the other (another trade secret that has been passed down through the centuries).

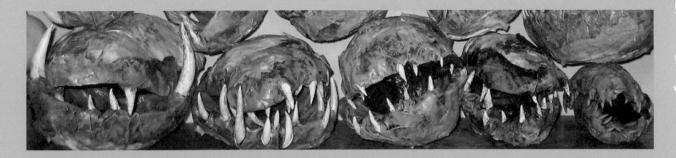

⹌⹌⹌IMPORTANT NOTE:⹌⹌⹌

You may not know it, but you are standing at one of those crossroads in your life. The question is, do you go directly to the Assembly stage right now, before you've put the cloth skin and paint on your jaws? Or do you follow my advice and cloth-mâché and paint them first?

Let's think about this. You've worked hard to get to this point and all you have to show for the effort is a pile of body parts. You desperately want to see your monster take shape and have no interest in doing more prep work. But it will be **much harder** to get the cloth around the teeth and the paintbrush into the mouth once the jaws have been inserted into the body—unless, of course, you want a monster with a wide open mouth (a fine option; I've made many such "screamers").

So, take my advice and apply the cloth-mâché and paint to the jaws first. This is called "delayed gratification," doing something **now** that will make your life easier **later.** This is something we don't do much in America. Want a car? No money? No problem. Borrow and buy it now. Need to finish your homework or business report or chores? No, watch "Deadliest Catch" instead. But I dare you to turn over a new leaf. Start small. Eat a cupcake upside down, frosting **last.** I know, I know, you are dying to know how many crabs the fishermen caught. But finish your important tasks **first.** Better yet, start your new resolution by completing your jaws first. It's easy. Just follow the steps starting on the next page.

PRE-CLOTH-MÂCHÉING JAWS

For this section you will need:

- Your jaws
- White glue
- Scissors
- Cloth strips
- A bright horizon

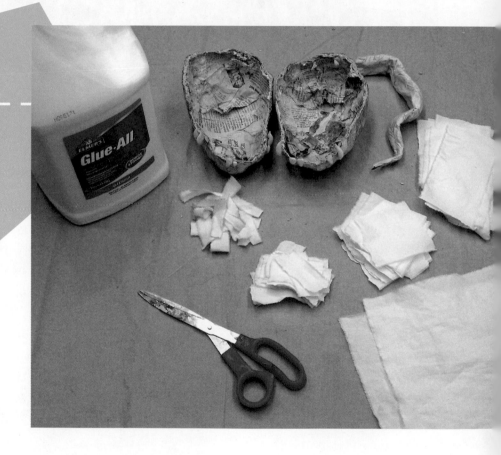

If you're following my advice and doing this before assembly, then good for you! If you are coming back to do this after assembly, good luck!

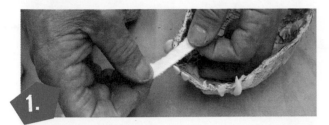

1.

Use a small strip of cloth.

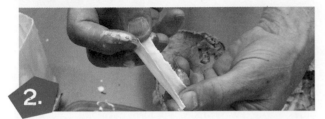

2.

Soak it in glue, squeeze out the excess, and fold it in half lengthwise.

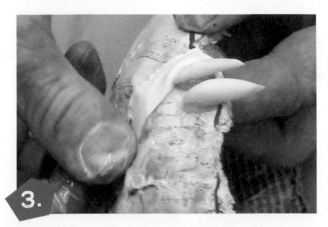

3.

Put strips in crisscross fashion around each tooth. Keep the folded edge of the strip against the tooth. This will make a nice gum ridge.

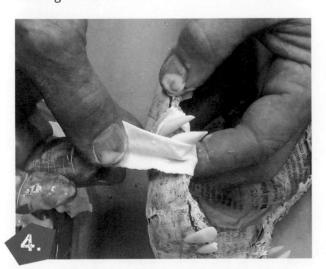

4.

Sometimes when I have teeth close together, I wrap a strip on the outside of a cluster . . .

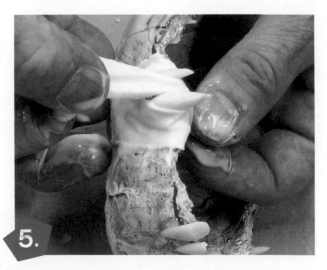

5.

. . . and then fold a strip on both sides and lay it in the middle. Wrap all the teeth in this manner. Use wider strips of cloth where there are wider gaps between the teeth.

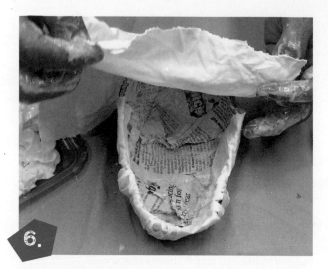

6.

To finish off the jaw, use a piece of cloth that is bigger than the jaw, soak it in glue . . .

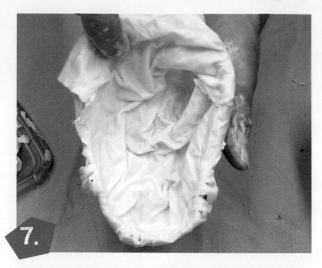

7.

. . . and lay it inside. Press the wet cloth against the sides of the jaw. Wrinkles will form naturally.

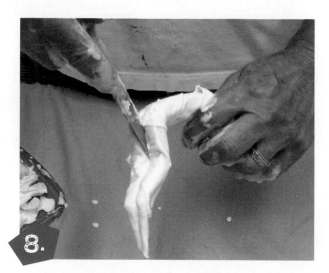

8.

If you've made a tongue, this is a good time to wrap it *loosely* in glue-soaked cloth. Use a knife to accentuate the crease in the middle.

9.

Lay the tongue into the lower jaw while it is still wet. I used a pencil here to keep the tongue raised. Put these jaws somewhere warm to dry.

PRE-PAINTING JAWS

You are doing well. Again, you can stop here, assemble, and paint the jaws later. I'm not going to lecture you anymore about the need for discipline in your life. If you think you can paint the insides of your mouth after it's attached, then go for it. But don't blame me if you find that you can't even see inside that mouth, much less paint it once it's stuck inside the body of your monster. Nope. I paint all my jaws in advance. I go to bed knowing my mouths are painted and ready to go. I'm a happy man.

If you want this same peace of mind, then follow these simple painting steps. This will be a cursory look at painting. You will get a more thorough treatment in the "Painting" section of the book.

1. Pick a dark color and paint the top of the tongue. Add a little paint inside the mouth as well.

2. While your brush is still wet, dip it into a lighter color and paint the inside of the jaw.

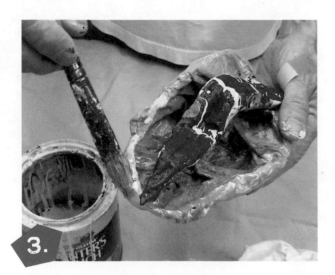

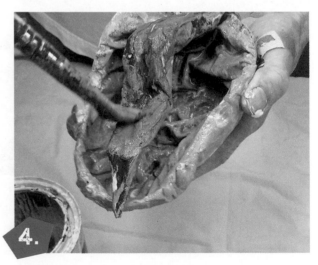

3. The idea is to avoid ending up with one color. Keep adding dark and light color. Blend them together minimally.

4. Don't get carried away with blending. Leave some of the colors swirled together.

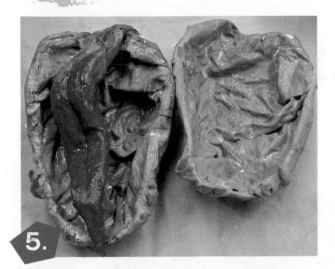

5. Do the same with the upper jaw. Let these dry before the next step.

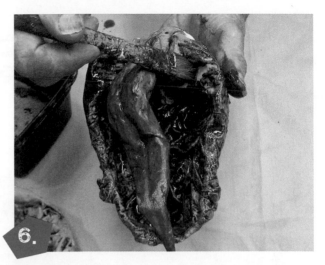

6. This step is actually optional at this point. Learn more about blackwashing in the "Painting" section. Water down some black paint. Paint the jaw quickly.

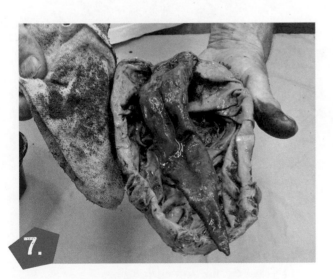

7. Before the black paint has a chance to dry, wipe the paint off. This is nice for monster mouths.

NOW, go to the "Assembly" section and watch your monster grow.

ASSEMBLY

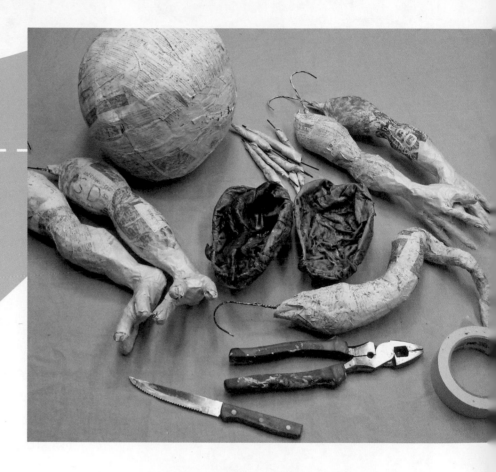

For this section you will need:

- All your body parts
- Your serrated knife
- 1½-inch-wide masking tape
- Wire cutters
- Claws
- To expect the amazing

This is where all the labor of making body parts begins to pay off. Your monster is about to be born. If you're the sensitive type, you might want a box of tissues around in case you burst into tears. I think I'm going to cry just telling you about this . . . oh wait, it's just something in my eye.

⁎-◠-◠. NOTE: ◠-◠-⁎
I followed my own advice and finished my jaws before assembly. You still have time.

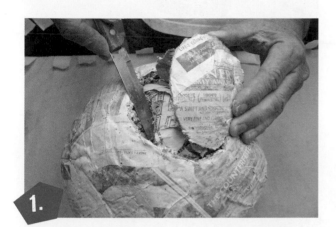

1.

Cut a hole in the body that you think is about the diameter of your jaws. Don't worry—you can make adjustments if you make it too big or too small.

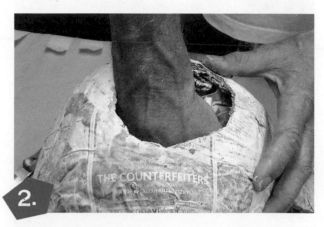

2.

Punch in the hole.

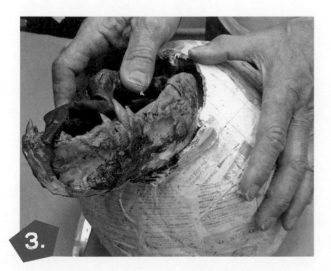

3.

Fit the lower jaw into the hole. If the hole is too small, cut it bigger. If it's too big, just add more tape on the next step.

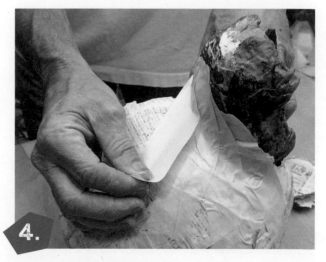

4.

When taping, start on the jaw and pull the tape diagonally onto the body. Then add another strip of tape, pulling it in the other direction. This will add tension and hold the jaw firmly in place.

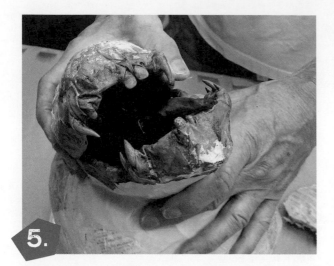

5. Place the top jaw over the bottom. Move it around until you catch an expression you like.

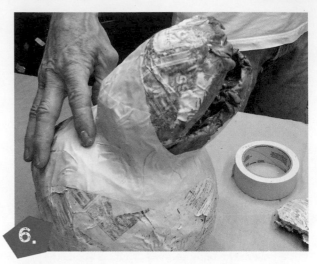

6. Use enough tape to secure both jaws.

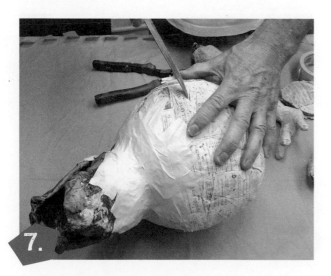

7. Cut a hole for a leg. Ideally, the hole will be slightly smaller than the leg so that you get a tight fit when you push the leg in.

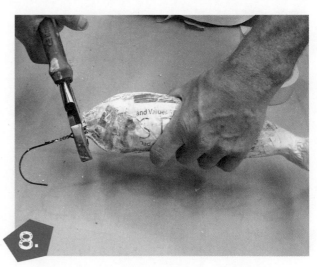

8. Cut the end of the hanger off the leg.

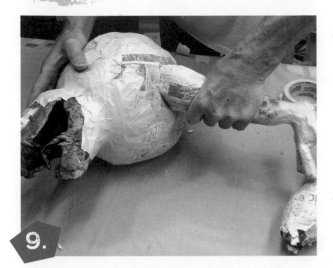

9. Stuff the leg into the hole. Don't worry yet about whether the leg is in exactly the right position.

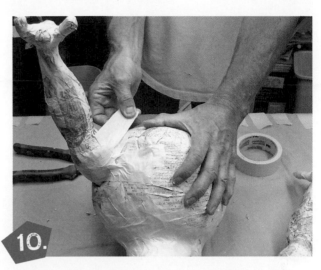

10. Use the diagonal taping procedure to secure the leg. Always keep the tape taut when applying it. Run the last few strips of tape in the opposite direction.

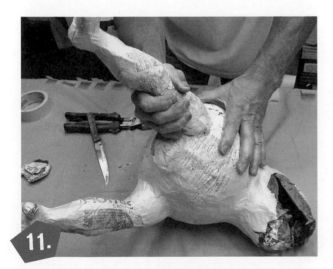

11. Cut the other leg hole. Stick in the leg and tape it to the body.

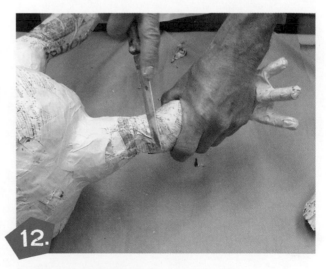

12. To make adjustments in the legs, partially cut the knees with the knife.

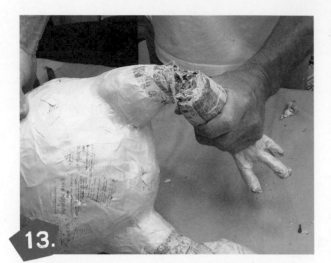

13.

Partially break the legs and bend them into the position you want. This is where you thank me for having you put clothes hangers inside the appendages. You're welcome.

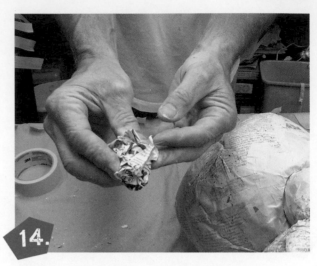

14.

Tightly crumple a small "kneecap."

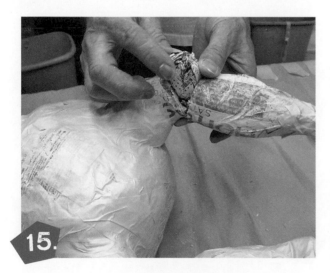

15.

Push it into the break in the leg and add tape.

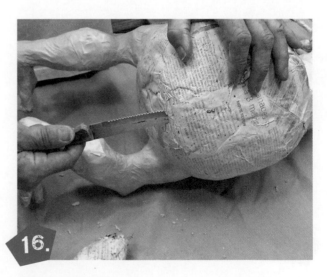

16.

Cut a hole for the tail.

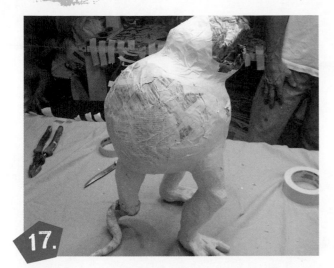

17.

Stand the monster up and make necessary adjustments for balance to the legs, tail, and all the joints. Add more tape when you've got it right.

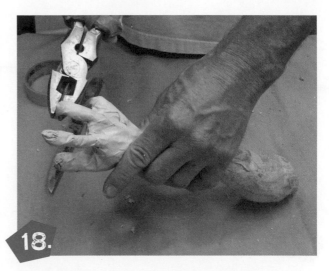

18.

Use pliers or wire cutters to bend some fingers on each hand.

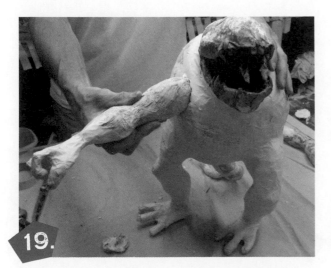

19.

Cut an arm hole and stuff the arm into it. Remember, don't plan this too carefully. Let the shape surprise you.

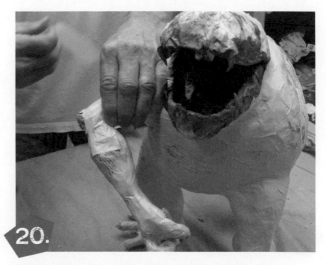

20.

Tape the arm securely to the body. Cut the elbow and bend the arm into the position you want. Make an elbow in the same way you made the kneecap.

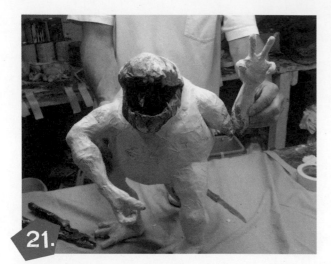

21.

Add the other arm. Experiment with both arms and hands and fingers and toes until your monster finds its "personality."

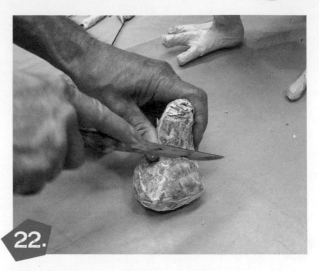

22.

Time to make a face. We'll start with a nose. Take one of your extra balls and cut it open.

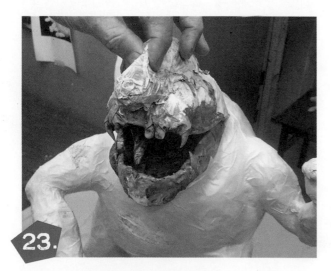

23.

See how it looks on top of the head. This is the time to mix and match various pieces of extra balls as you make the monster's face. Have fun with this. Try different looks. Try pinching the nose.

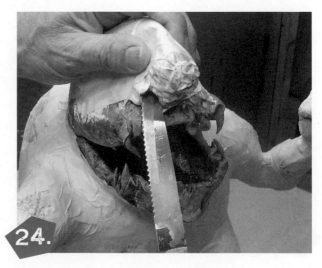

24.

Use the knife to add appropriate nostrils.

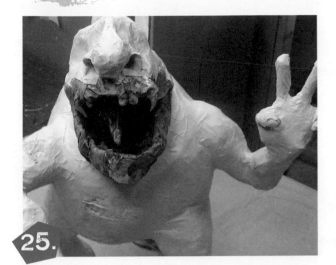

25. Add tape to finish off the nostrils.

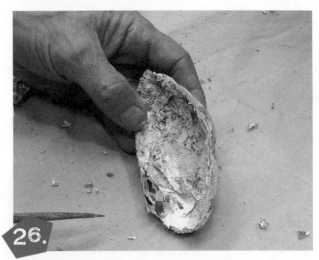

26. Cut open a small mâché ball and empty it out to use for the ears.

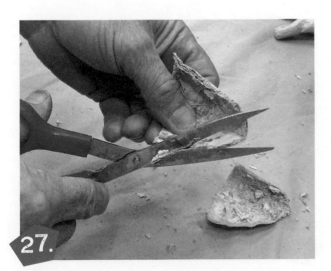

27. Shape the ears with scissors.

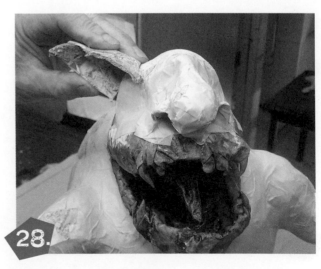

28. Tape the ears onto the head.

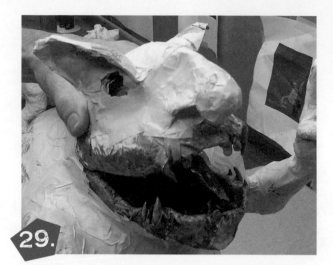

29. Use the knife to cut ear holes.

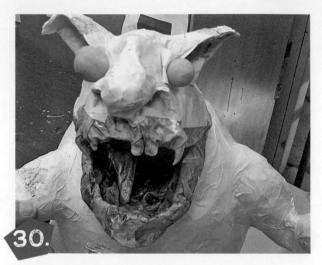

30. Finally, play around with various eyes and different positions for the eyes. I've chosen to use Super Sculpey eyes for my monster. This position? No.

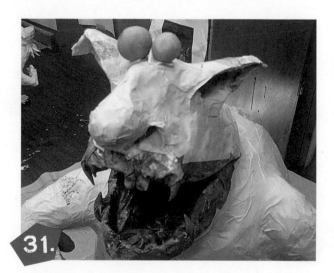

31. A little better.

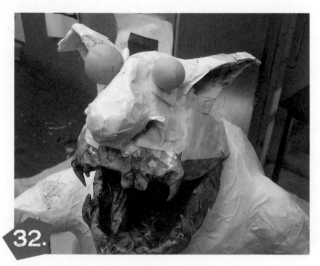

32. Yes!

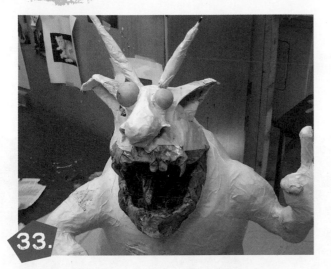

33.

Add a few horns. Or many. Or none. Note that in the monster world, the difference between "horns" and "tentacles" is subtle, like the difference between french fries and spaghetti.

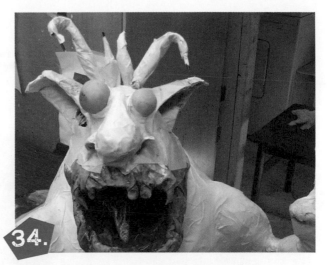

34.

Bend the horns or tentacles as you wish.

35.

Finally, use hot glue to add some claws, if you made them. You are now ready for the cloth-mâché skin.

36.

One day I caught Eddy reading the paper. I thought I was going to be rich, put him on TV. The wonder cat! But then I realized he was just looking at Britney Spears. What a disappointment! I gave him only dry food for a week for trying to trick me.

CLOTH-MÂCHÉ

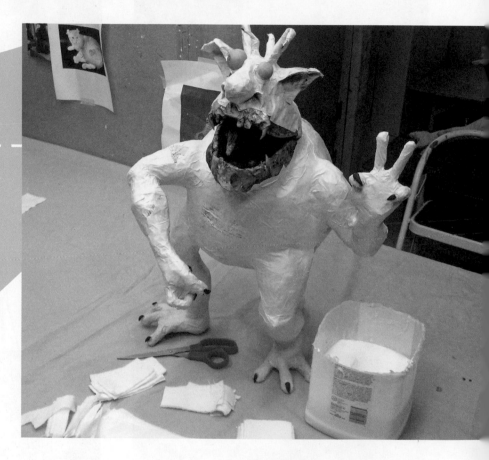

Time to put some skin on your beast. This process takes a bit of getting used to. It will seem awkward at first, and there will be times when you really don't want to put your hands into the glue one more time. But trust me, this will be worth it. You will be amazed at the strength and detail you can achieve with this step. Be brave.

Be persistent. It's understandable to be reluctant to start. Go ahead and make yourself a sandwich first and think about it. After that, get going!

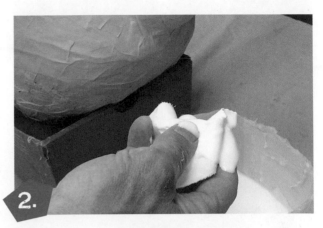

1. It's easiest to do this in stages. I like to cloth the bottom of a monster first. Find a way to prop your beast upside down. A box works well.

2. Unlike the papier-mâché steps, you *do* put the cloth strips *into the glue*. Soak the strips and squeeze out the excess.

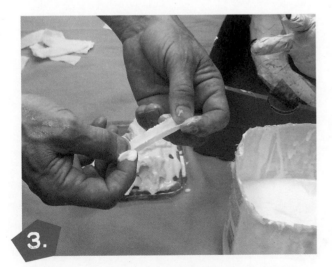

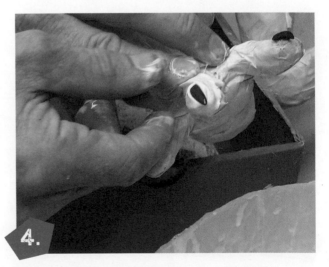

3. To emphasize the fingernails and claws, fold a strip of cloth . . .

4. . . . and wrap the folded edge around the claw.

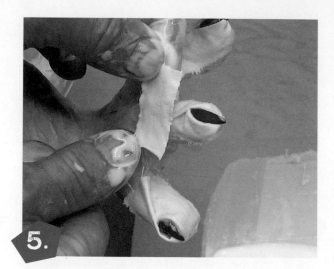

5.

Wrap other unfolded pieces of cloth around the toes.

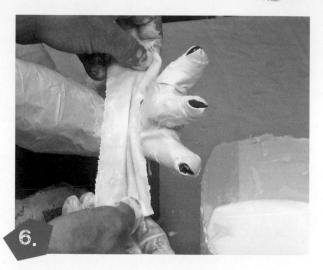

6.

Add other various-sized pieces of cloth to the rest of the foot. Wrap larger strips around the ankles and the rest of the leg.

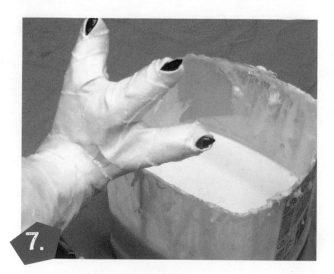

7.

Use small pieces to cover any last spots that don't have cloth.

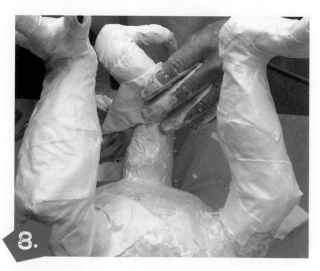

8.

Starting at the end of the tail, wrap longer strips of cloth around the tail, working your way up to the monster's bottom. Finish covering the underside of the project and let it dry overnight.

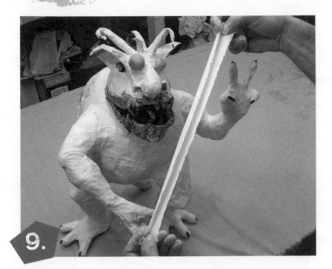

9. Once the underside of the monster is dry, turn it over and put cloth on the hands and arms. Then it's time for some real fun—finishing the face. Start with the lips. Fold a long strip of cloth.

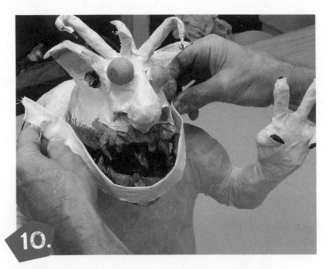

10. Wrap it around the mouth with the folded edge up. (This will make full lips. You **do** want full lips on your monster, right?)

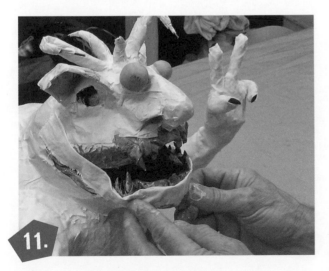

11. Pat down the torn edge against the face. Pull the lip out in some places and push it in in others. Experiment with a smile or a pout.

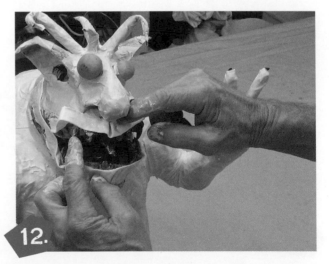

12. Similarly, add an upper lip. Perhaps put a crease under the nose. Or pull the lips back to expose more teeth. As I've said many times, have fun with your face. Play with these lips until you get the perfect expression. You'll know it when you have it.

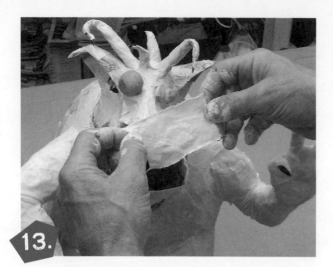

13.

For the nose, take square or rectangular pieces of cloth, soak them in glue . . .

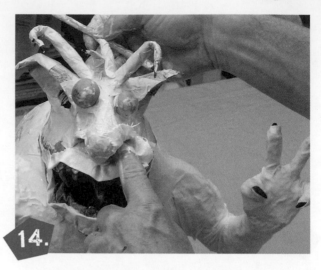

14.

. . . and stick them in the nostrils. Cover the rest of the nose with small pieces of cloth.

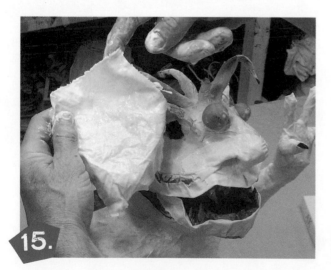

15.

Do the same with the ears: Use square pieces of cloth.

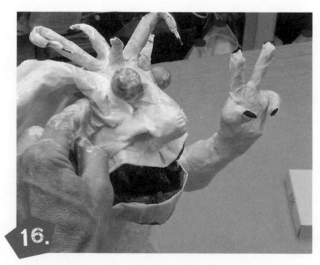

16.

Push them into the ear canals. Fold the rest of the cloth around and behind the ears. Wrinkles will naturally form inside the ear exactly where wrinkles should be. It's amazing.

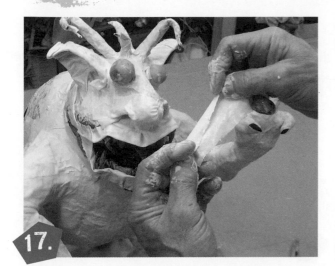

17.

Fold another piece of cloth to use for an eyelid.

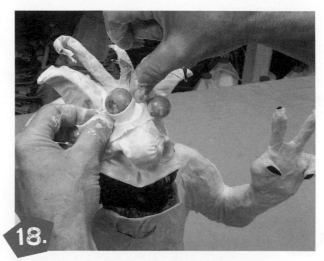

18.

Pull it around the eye. Putting a square piece of cloth around a round eye will always create nice wrinkles and bags, characteristic of all monsters (and old monster makers).

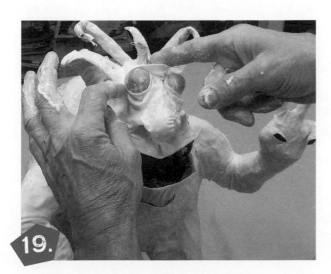

19.

Do the same for the top of the eye.

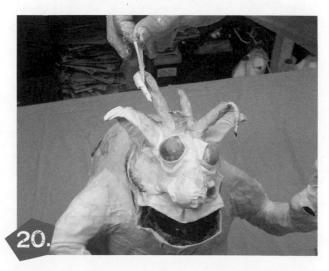

20.

I wanted to add something special to my horns, so once again I folded a long strip of cloth and wrapped it around from top to bottom. The fold added a spiral to the horn, which I emphasized with paint later.

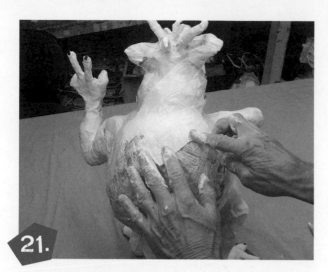

21.

Finish adding cloth to the rest of your monster, then put it somewhere warm to dry.

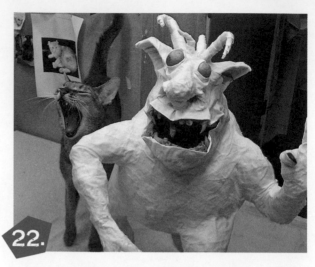

22.

Eddie the cat says, "Whaaaaaa, I want attention now!"

Q: My 3- and 4-year-old children are afraid now that I've filled the house with monsters. What do I do?

A: Tell them that it is your house until they turn eighteen and that you are an adult and can do whatever you want.

PAINTING

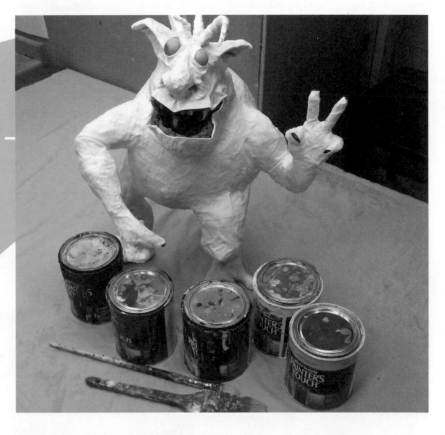

For this section you will need:

- Paint (see next page)
- A wide paintbrush
- A thin paintbrush
- A life

I use a painting method that is technically called "fast and furious." It essentially involves painting a second (or even a third) color while the first coat is still wet. We didn't use balloons because we didn't want too much symmetry when we built the monster, and we don't want a monochrome paint job. At least for monsters, it's just more interesting if the colors are smeared together. Now, you are going to get some paint on your hands, particularly during the "blackwash" stage. Don't worry, though; it will give you that cool "artist at work" look. But leave your ear on.

I prefer latex paint when it comes to painting sculptures this size. The cloth-and-glue combination will soak up latex paint beautifully. It will make dragon wings feel like leather and will also give enough waterproofing to put a monster in a bathroom. I have a dragon over my bathtub. (Don't you?) You can get quarts of latex paint that are very close to the primary colors at big hardware stores. If you can't get latex paint, any water-based paint will work. Buy red, yellow, blue, and, of course, black and white.

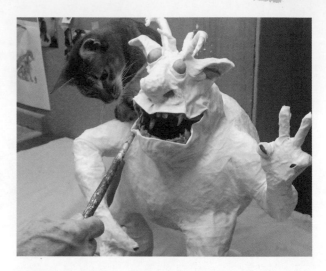

Eddy wants to paint too.

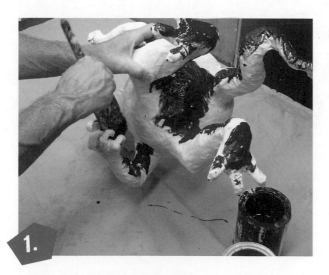

1.

I like to start with some dark color. Turn the monster upside down and slap some paint underneath the feet, on the underside of the arms, legs, and tail, and under the chin.

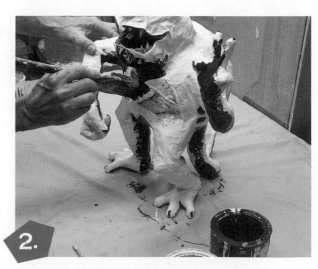

2.

Turn the monster back over, then dip the wet brush into a lighter color and slap some of that paint on the areas that aren't covered in the dark paint. Err on the side of too much paint rather than too little.

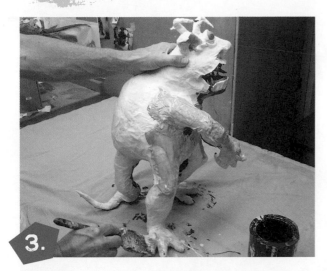

3. Work fast, travel light, slobber the light paint everywhere.

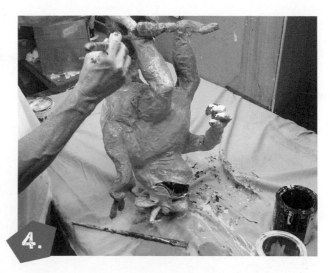

4. Where you bump into the darker paint, blend the two colors together.

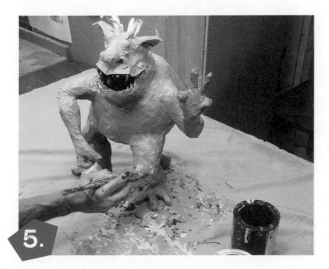

5. Don't get too carried away with the blending. You don't want to turn it all into one even color. Be brave enough to leave splotches of paint. You will *want* to keep blending, but stop. Stop!

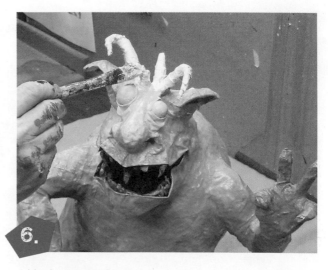

6. Add whatever color you want to the horns or other appendages. Let dry overnight.

BLACKWASHING

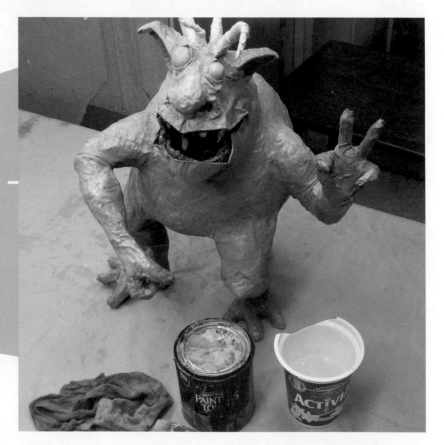

For this section you will need:

- Black paint
- Paintbrushes, one wide and one thin
- Water
- A damp rag
- A heart of gold

I call this part of the painting process "blackwashing" because I wash the monster with black paint and then wipe it off before it dries. You might fall in love with the bright and vibrant colors of your newly painted monster. You might not want to cover the cute little guy with black. I can only remind you of what Arlo Guthrie used to say: "You can't have a light without a dark to stick it in." Of course, that quote might have nothing to do with painting. I just like Arlo Guthrie. Trust me one more time—once you blackwash, the colors will seem even more intense and beautiful, like that "endless skyway and that golden valley" (Arlo's dad).

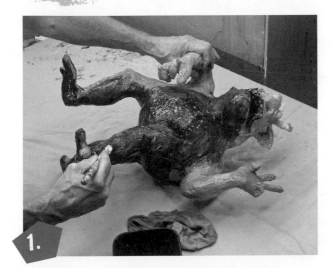

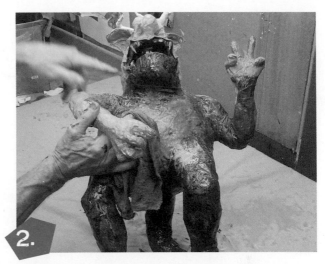

1. Pour some black paint in a container. Add enough water to loosen it up. I would tell you exactly how much, but I've never measured. Experiment—it will work no matter what. Quickly paint a section of your monster.

2. Before it dries, wipe off the black paint. While you are doing this, think of shadows. Leave more black on the undersides of the monster.

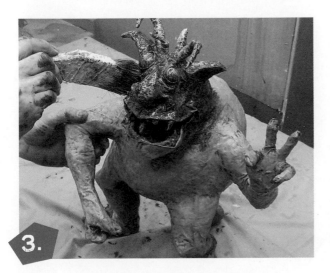

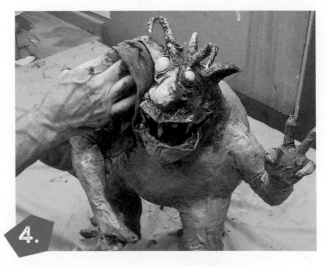

3. I like doing the face last. No particular reason.

4. You have to admit, he looks much better.

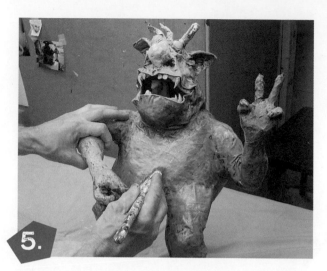

5.

The black paint may dry too quickly in places. Or it just might end up darker than you prefer. If this happens, put a small amount of paint on your brush and add back some color.

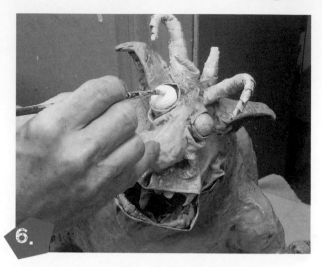

6.

Hold your breath. Add a little white here . . .

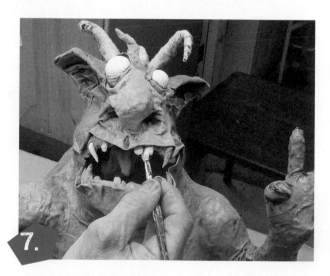

7.

. . . and a little white there.

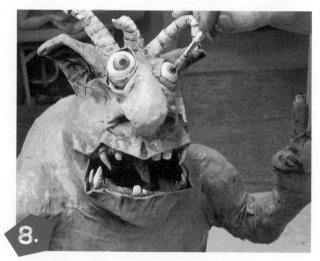

8.

Add a couple irises and pupils.

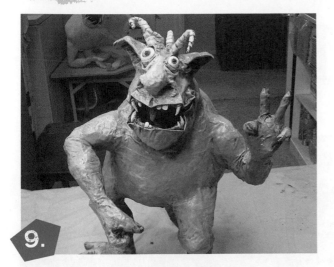

9.

Q: I now make monsters night and day and my grades are falling. What should I do?
A: Eat lots of candy.

And your monster awakens! He says, "Peace, monster makers."

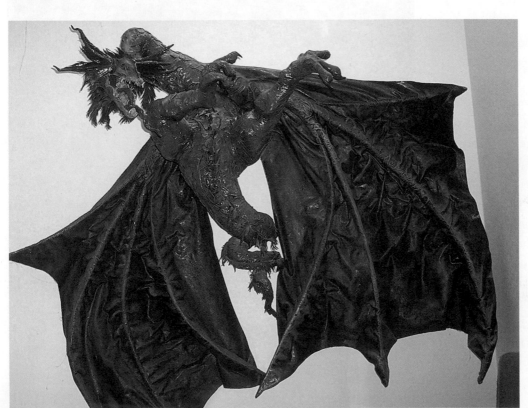

Oh, by the way, here's my bathroom dragon.

Monster Marionette

Many people ask me why I don't make monsters like they do in Hollywood—monsters that move. Simply put, I like to find a certain look, an attitude, a pose, and then freeze it. I like sculpture. But I make an exception with puppets and marionettes. I still insist that this particular monster have a frozen facial expression. But I don't mind if he wants to dance.

The secret to a great marionette is in the joints. They must be supremely loose and flexible. By now you know that I'm a big fan of wire clothes hangers. Having them inside your papier-mâché is ideal for making marionettes. These instructions will not be presented in the usual beginning-to-end order. I want you to see where you are headed before you start the early steps. These instructions are meant to complement the Basic Monster instructions. If you skipped to this part of the book, go back and look at that section first.

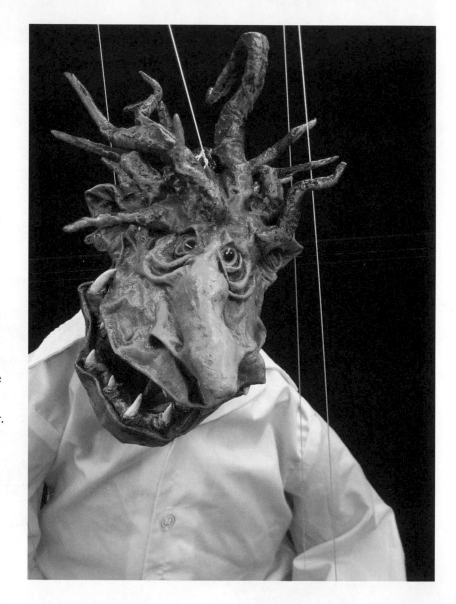

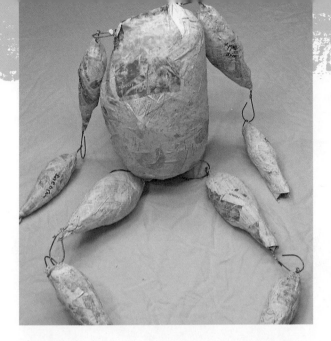

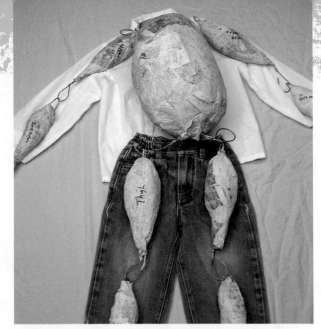

This is what your basic marionette body will look like after you've completed the papier-mâché. Essentially, you'll mâché the pieces of the arms and legs separately and then hook them together using the clothes hangers.

I've decided to put kid's clothes on this marionette. I'll use the sleeves and pant lengths to guide my decisions about the size of the pieces.

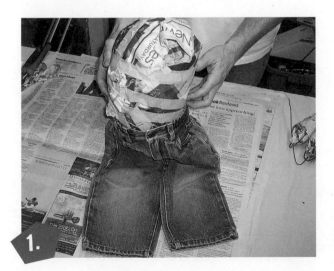

1.

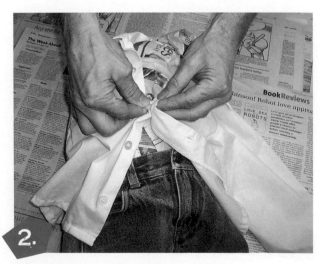

2.

If you choose to use clothes as well, start by crumpling balls that fit inside the pants . . .

. . . and the shirt.

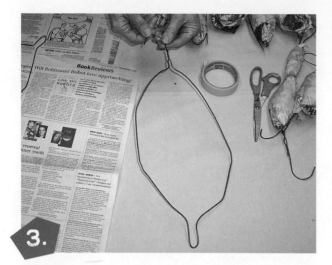

3.

Bend two clothes hangers to fit the ball, but leave little loops at the end.

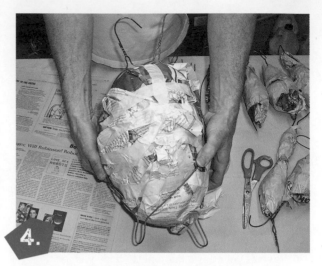

4.

Stuff the ball inside the hangers and tape it to the hangers. Orient the hangers like you see in the picture, one a little rotated on the ball from the other.

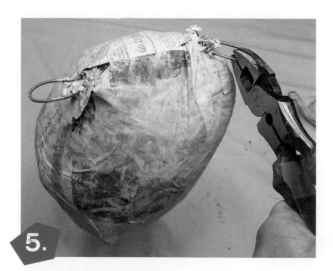

5.

Cover the ball with papier-mâché. After you've covered it, you can bend the loops outward. You will be hooking the monster's legs onto these loops later.

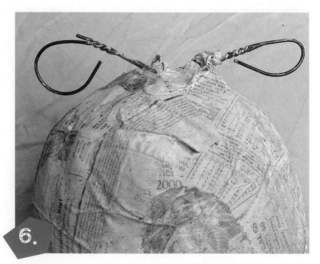

6.

Use pliers to curl the hangers on the top side of the ball. You will be hooking the monster's arms to these later.

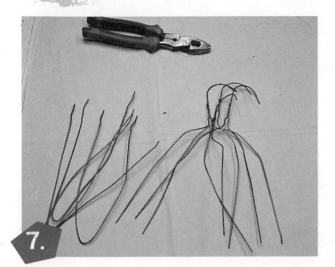

7.

Usually, we would use whole hangers for each arm and leg. This time we'll stretch them lengthwise and cut them in half.

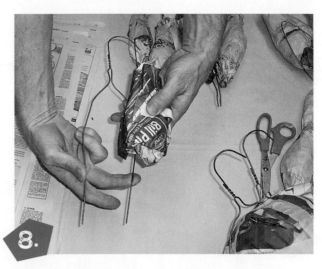

8.

Crumple a "thigh" and stick it inside the half hanger. Wrap with tape.

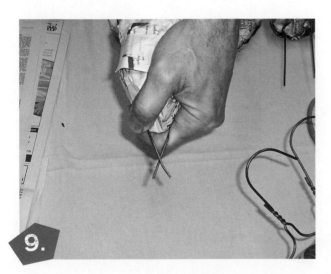

9.

Cross the wires sticking out of the bottom.

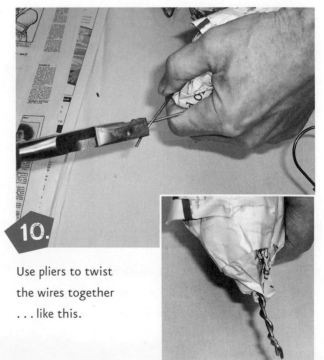

10.

Use pliers to twist the wires together . . . like this.

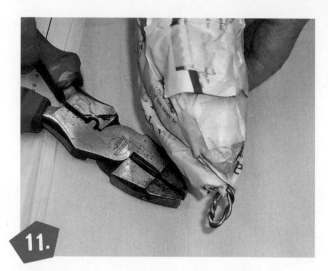

11.

Bend the twisted wire into a loop. The bigger you can make these loops, the better. If you are making a large puppet, consider using a whole hanger instead of a half for these parts.

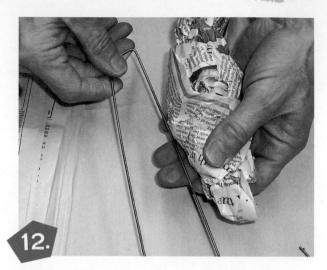

12.

Crumple a "calf" and put it into the other half of the clothes hanger.

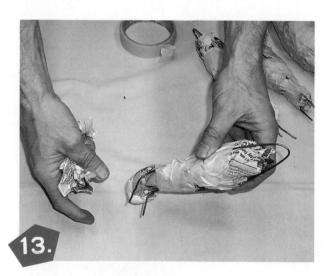

13.

Leave the closed end of the wire without paper. This is where you will hook the calf and thigh together. You will use the other ends of the hanger for a foot.

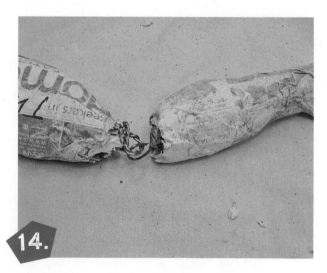

14.

Use the wire hooks to attach the thigh and the calf together.

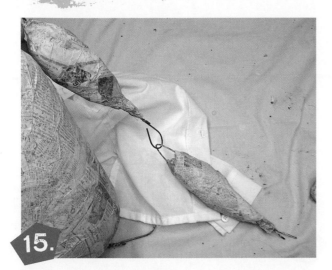

15.

Repeat steps 7–14 to make the other leg and both arms. You will hook the upper and lower parts of the arm as shown.

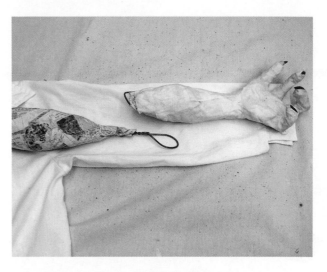

Note: You will probably want to add hands and feet before you close the loops.

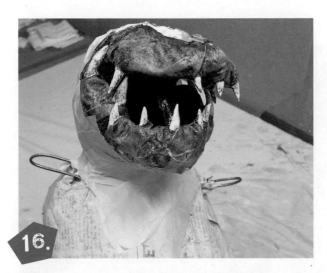

16.

Don't forget to make the head. Put the jaws between the wire loops and build the face.

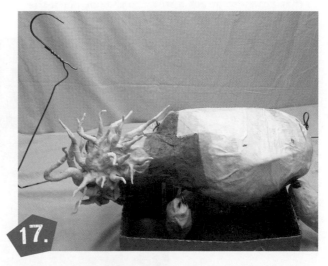

17.

You will need a string attached to the top of the head. To support the puppet's weight, connect the string to a wire that runs entirely through the marionette. Cut a hanger at an angle to make a sharp point. Push it into the head and through the body until it comes out the bottom.

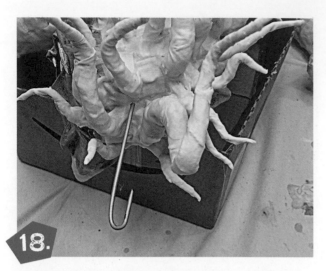

18.

Cut off the excess hanger and bend the wire into a hook. At this point you can push this hook partially back into the head. This will poke the wire out the bottom even further. I hook this bottom wire as well so that I can also attach a string to the bottom of the marionette.

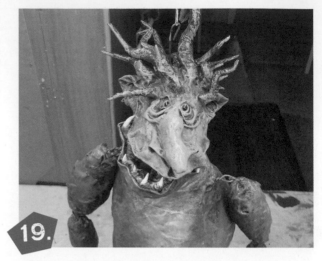

19.

I use the hook on the top of the head to hang the marionette while I make finishing touches.

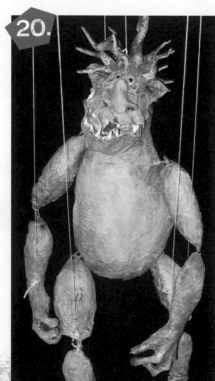

20.

If you study marionettes, you'll find that there are many variations for string placement. For this one, I chose to connect strings to the head and the bottom (so you can tilt him), the wrists (I poked wire through the wrists and made loops), and the knees.

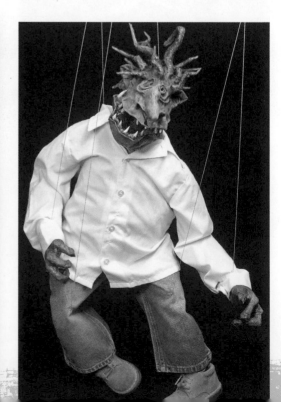

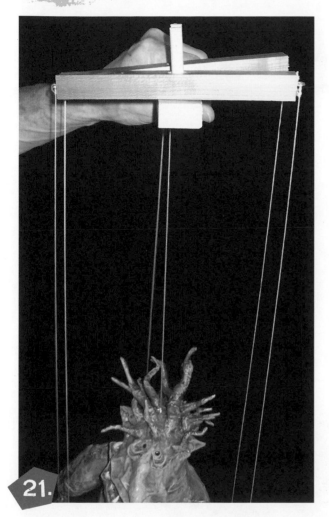

21.

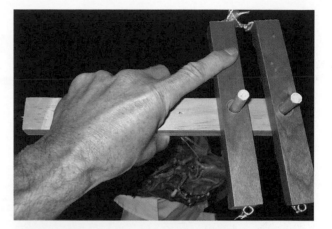

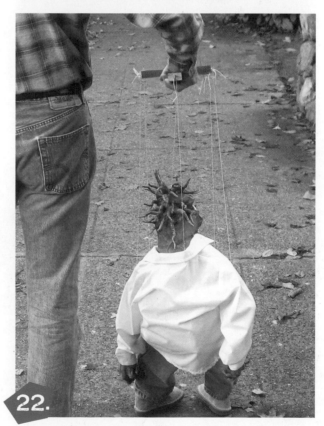

22.

Hand-control schemes vary greatly as well. Basically, you just need some pieces of wood arranged in a way that will connect with the strings. In this marionette I'm using a double "T." I attached a hook in the middle of the T that connects to the head. The bottom of the T connects to the bottom of the marionette. The two T-crosses control arms and legs. I made it so that the crosses on the T can be removed so that the arms and legs can be controlled separately.

Take your little guy out for a walk. Tell the neighbors that you couldn't afford a dog.

Trophies

I think most people who have animal trophies consider bigger to be better. Haven't seen too many mounted squirrel heads. Other people don't want anything to do with a moose over the fireplace. But what about a relatively big dragon-ish looking thing? Something you didn't have to hunt down and kill (luckily). Interested?

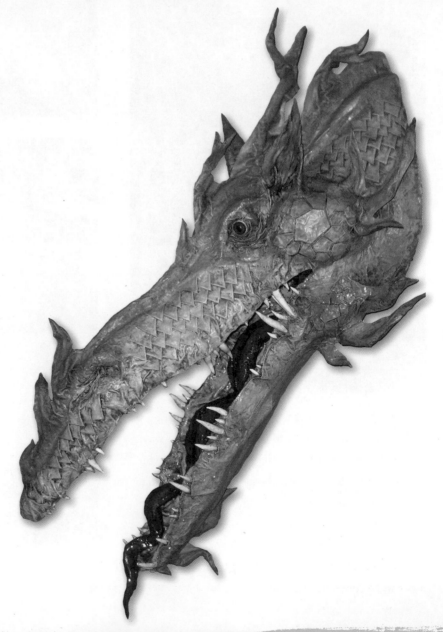

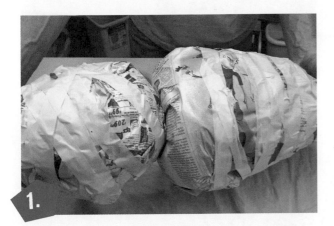

1. Since you want larger jaws than usual, put two or more crumpled balls together.

2. Tape the balls together and add papier-mâché.

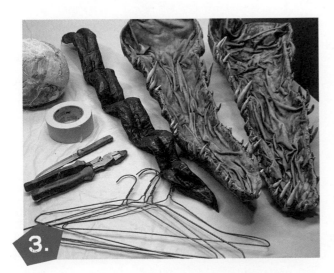

3. Make yourself a set of imposing jaws and a long tongue. See "More About Jaws and Tongues" (p. 119) for help with these larger jaws. To make this trophy, you will need a few clothes hangers and extra mâché balls, along with the jaws.

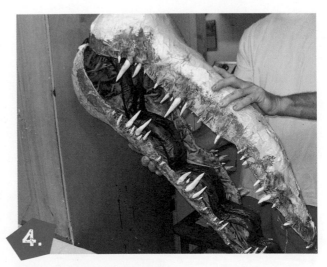

4. Hold the jaws up to a wall to get a sense of how you want your trophy to hang.

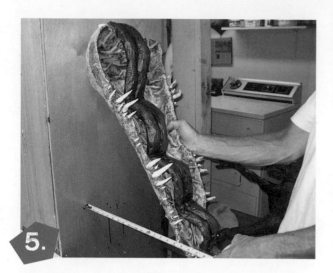

5. Measure the distance from the wall to the end of the lower jaw.

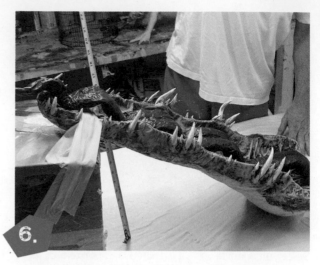

6. Using a cardboard box, slide the jaw up until you match this measurement. Tape the jaw to the box.

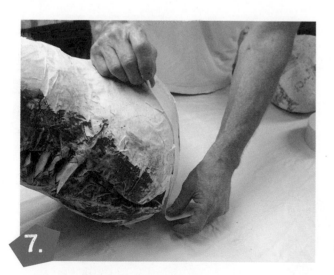

7. Put the top jaw over the bottom and add just enough tape to keep the ends of the two jaws together.

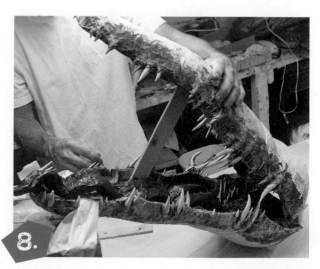

8. If you want the jaws to be open, prop something between them for support while you perform the next steps.

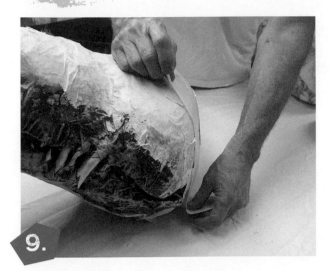

9.

Cut a papier-mâché ball in half to augment the base (where the trophy will meet the wall).

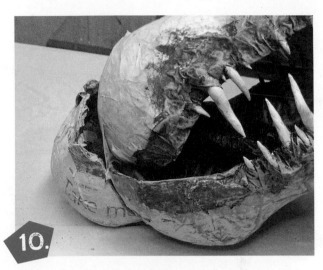

10.

Push the half-ball under the end of the jaws. You might end up crushing one edge of the ball. That's okay. You are just trying to fill out the neck.

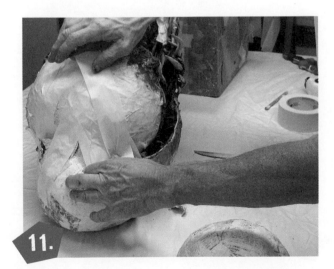

11.

Add some tape.

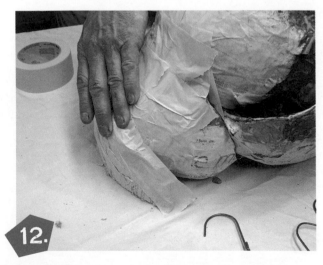

12.

Cut additional pieces as needed and tape them to the base.

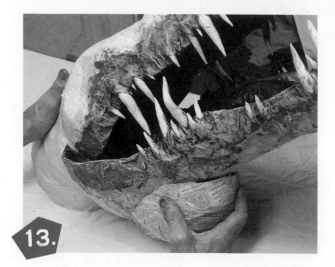

13. Tape other pieces under the jaw. Here I used a half ball to make a gullet.

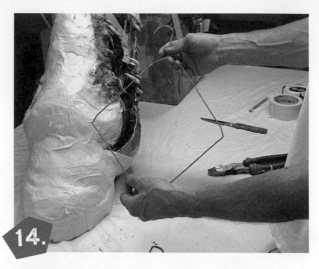

14. Use clothes hangers to provide structure and to help with the weight of the head. Stretch a hanger.

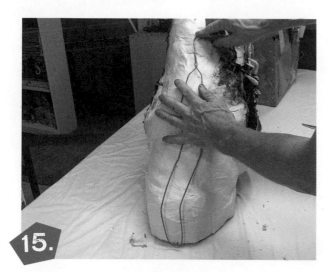

15. Bend the hanger to conform to the profile of the upper jaw.

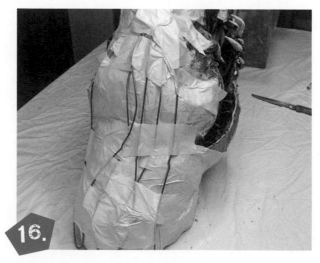

16. Tape the hanger to the jaw. Wide tape works best here. Add several more hangers—in fact, the more hangers, the better. When we are finished, we will use the ends of these hangers to hang the trophy on the wall.

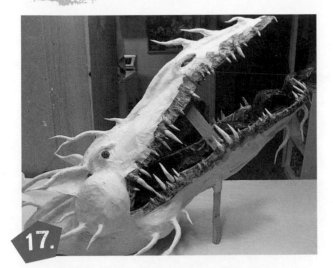

17. Use more papier-mâché balls to add ears, horns, bulges, and all things dragon-like. Note that I replaced the box with a stick for support.

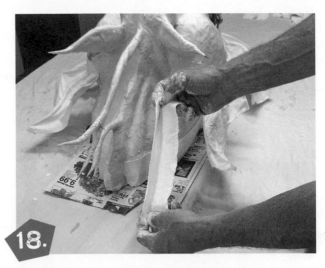

18. Begin the cloth-mâché phase: Fold large strips of cloth dipped in glue . . .

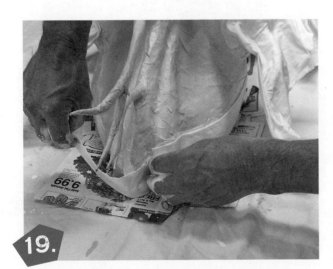

19. . . . and rim the base where the trophy will meet the wall.

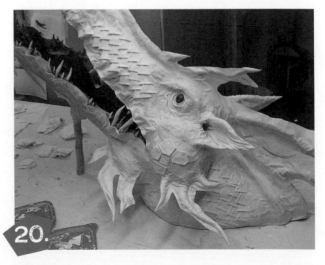

20. Definitely add scales and other details (see "Delightful Monster Details," starting on page 104). After the cloth-mâché is dry, the head will be strong enough that you can pull out the stick supports. Paint the trophy using the techniques described in the Basic Monster instructions.

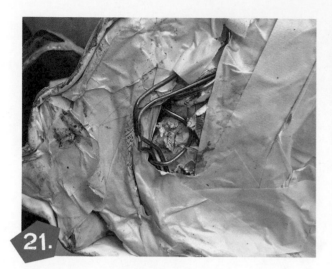

21.

I use a pretty low-tech method to hang trophies. Put a long screw into the wall (it's good to hit a stud). Loop the ends of the hangers that you put inside the trophy over the screw.

Q: I notice you only make monsters. Can you make something "cute" out of papier-mâché?
A: No.

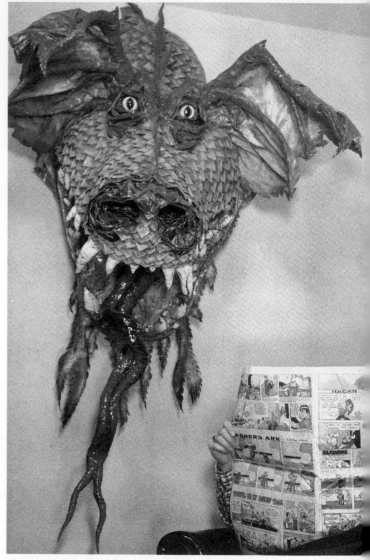

Try your hand at something a little bigger next time.

Papier-Mâché Piggy

In the world of woodworking, making the perfect box is a sort of rite of passage. I think in the papier-mâché world, it's creating the traditional piggy. I really don't know why, but virtually every papier-mâché artist I know has made one or two. There is some deep-seated need to test ourselves with this particular subject matter. I think it might have to do with previous lifetimes. Maybe we were piglets and our mothers were taken off to be made into bacon and somewhere deep in our subconscious we are determined to re-create them.

Either way, if you are serious about papier-mâché, you are going to make a piggy sooner or later. Now, for those of you who are inexplicably drawn to this particular project, I've decided to test my little reincarnation theory. I've written many of these instructions in "Pig." (Of course, I've also added some commentary in "Human," just in case you're a bit rusty.)

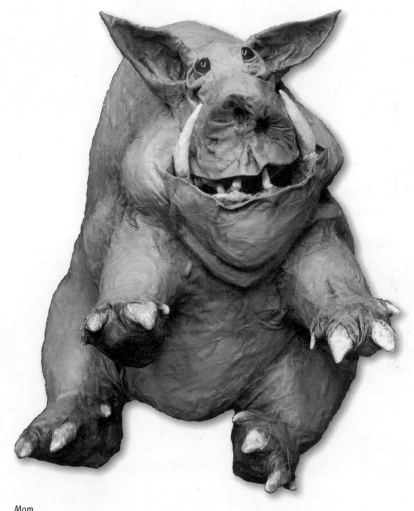

Mom

Oink oink oink oink: Oink oink. Oink. [1]

Oink oink oink (oink oink oink, "Oink").

[1] Oink oink oink oink oink oink oink. Oink oink oink. (Make sure you look over the Basic Monster steps first!)

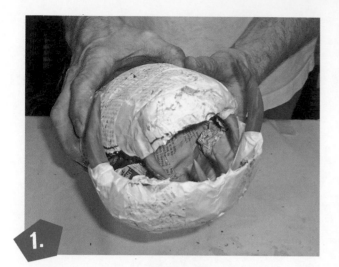

1.

Oink oink oink oink, oink oink.

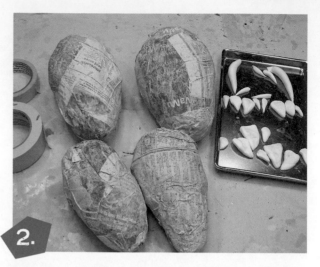

2.

Oink oink oink oink. Oink oink oink oink oink. (Yes! Fatter legs!)

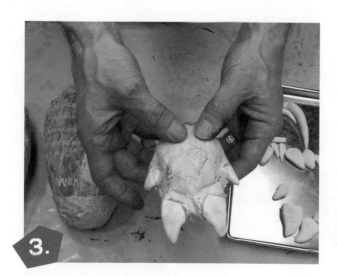

3.

Oink oink oink oink . . .

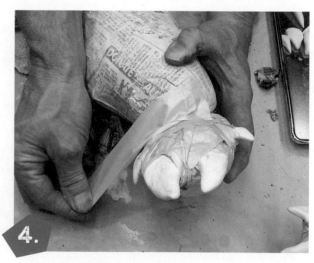

4.

. . . oink oink oink oink oink oink.

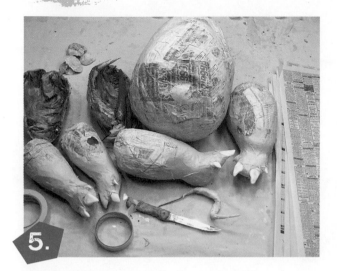

5.

Oink oink oink oink oink.

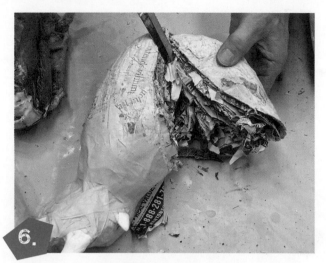

6.

Oink oink oink oink oink oink oink oink oink oink oink oink oink oink oink. (Save the piece you cut off for jowls.)

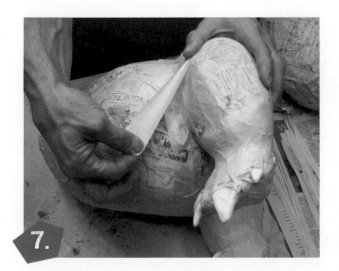

7.

Oink oink oink, oink oink, oink, oink, oink oink.

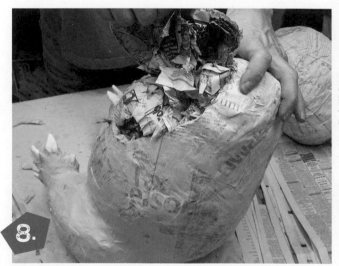

8.

Oink oink.

9.

Oink!!! (Max!!!)

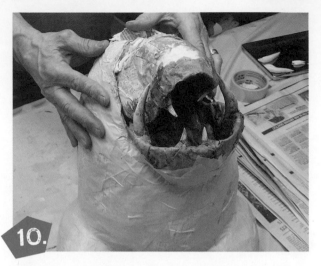

10.

Oink oink oink oink oink oink oink oink oink oink oink oink oink oink oink. (Push the top part of the head into the hole as well.)

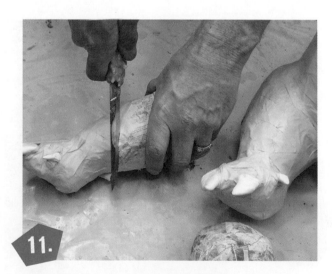

11.

Oink oink oink oink oink oink oink oink oink oink oink. (Cut the front leg at an angle, like you did for the back legs.)

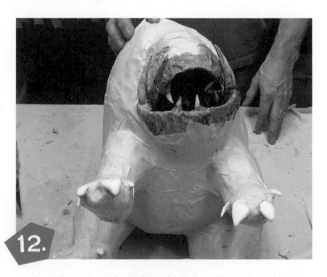

12.

Oink oink oink oink oink oink oink oink oink oink oink oink oink oink oink. Oink oink oink oink oink oink oink oink oink oink oink oink oink oink oink oink.

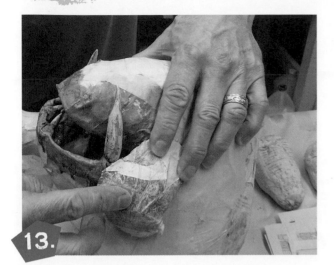

13.

Oink oink oink oink: oink . . . (Use the piece you saved from the back leg . . .)

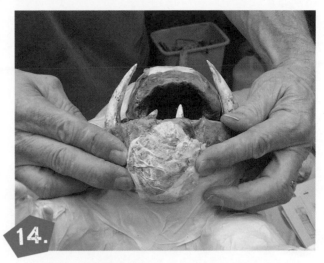

14.

. . . oink oink oink oink oink. (. . . and another piece of a ball for the chin.)

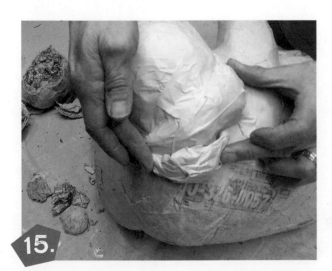

15.

Oink, oink, oink oink oink. Oink oink oink. Oink oink oink oink. Oink oink oink oink . . . (Roll pieces of paper. Wrap with them with tape. Use them wherever you want rolls of excess pig. Above the thigh . . .)

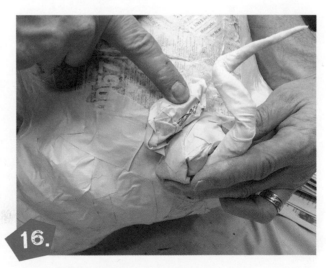

16.

. . . oink oink. (. . . the tail.)

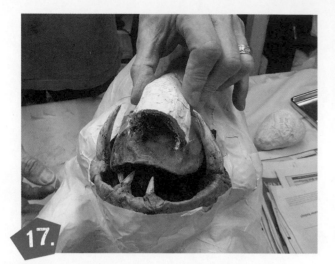

Oink oink oink oink oink oink oink oink oink. (Cut another piece of mâché ball and use it for a nose.)

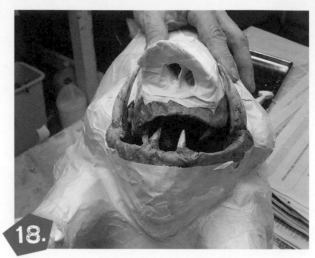

Oink oink oink oink oink. (Use masking tape to create nose holes.)

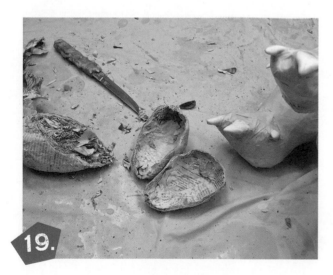

Oink oink oink oink oink oink oink oink oink oink oink.

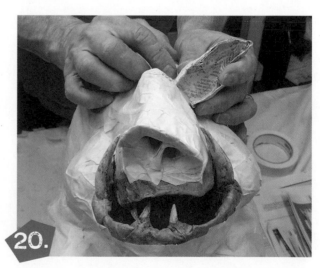

Oink oink oink oink oink.

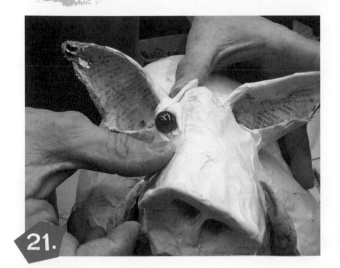

21.

Oink oink oink.

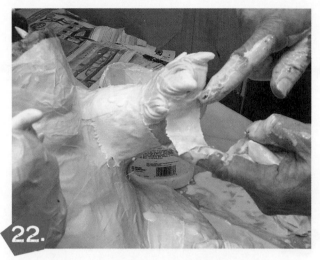

22.

Oink oink oink oink. (Start cloth-mâchéing at the feet and work up.)

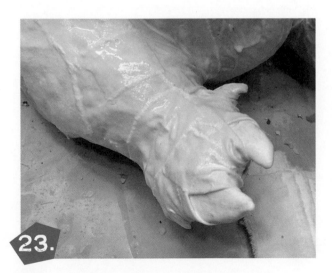

23.

Oink oink oink oink oink oink oink!

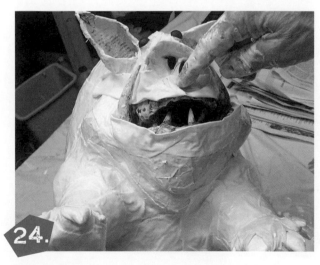

24.

Oink. (Lips.)

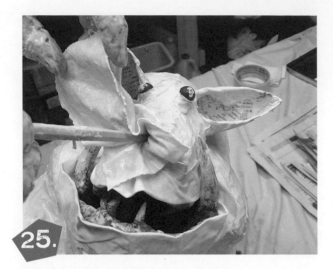

25.

Oink oink oink, oink oink oink, oink. (Push cloth inside the nose.)

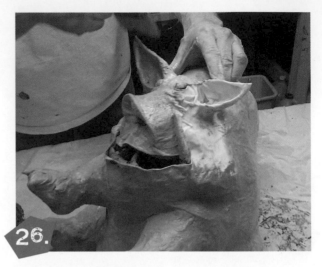

26.

Oink oink. (Paint pink.)

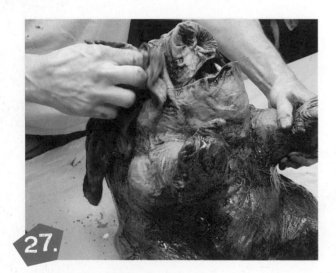

27.

Oink. (Blackwash.)

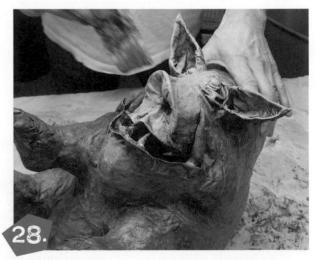

28.

Oink oink, oink oink oink oink oink (oink oink oink). (Add back some highlights [where it got too dark].)

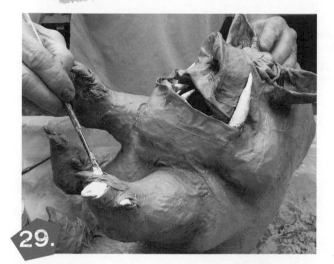

29.

Oink oink, *oink*.

Q: Can you keep your monsters outdoors?
A: Certainly, but you must build a little monster door so that they can come and go.

Oink oink oink oink oink oink. Oink oink oink oink, oink oink, oink oink, oink oink, oink oink oink. Oink oink oink oink oink oink oink oink oink oink. Oink, oink oink, "Oink oink oink oink oink oink oink!"

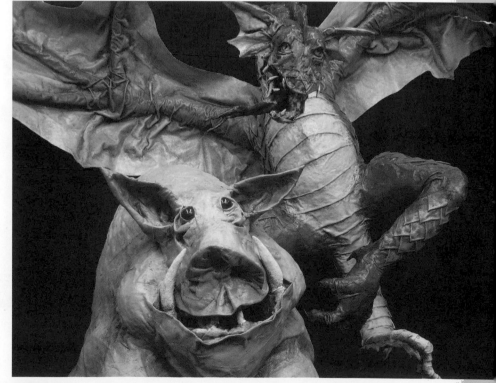

Oink Oink Oink

Monster Doll

There is nothing quite so satisfying as taking something cute and transforming it into something monster-ugly. Don't tell me you haven't done it. Never erased the eyes out of a model in a magazine and drawn your own ugly eyes in? Or twisted Barbie's head around? Or put a talking Barney into a vise and squeezed his head? Sure you have.

I'm sorry—I should explain that these remarks are primarily aimed at my younger audience. Okay, so I'm really talking to teens and preteens. Okay, preteen and teenage boys in particular. And immature adults, like me. Let's face it, altering dolls is a wonderful, semi-harmless outlet to relieve stress . . . and bug people. I must warn any normal people who might be reading this, if the piggy project was the cutest section in the book, then this is certainly the ugliest, so much so that my wife and children won't even be in the same room with this finished "thing."

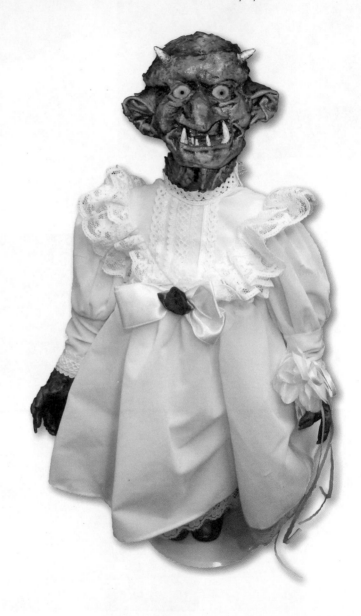

1.

To do this you need a cute doll. If you can't find one at home, there are many at secondhand stores. Be brave and buy one. Say that you are buying it for your little sister. No papier-mâché this time. We jump right to the details and cloth-mâché stage.

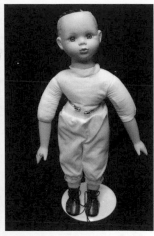

2.

Take off her pretty dress and hair. Note that she still looks cute.

3.

Take out the brains and the eyes. Now we're getting somewhere.

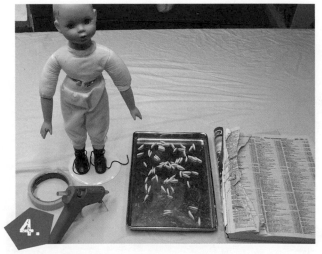

4.

You'll want some telephone-book paper, tape, glue gun, and small Fimo teeth for this part of the transformation.

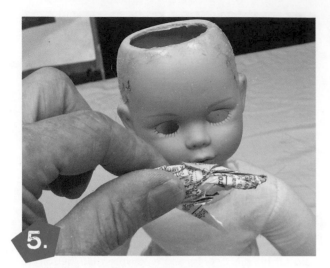

5. Basically, we are going to sculpt with small pieces of paper and then cover with a cloth-and-glue skin. Start twisting pieces of the phone book paper.

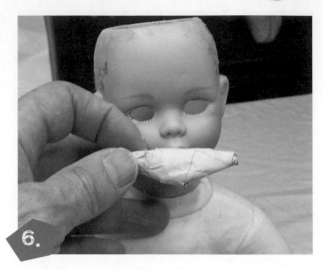

6. Wrap them with tape. I will use this piece to make a chin.

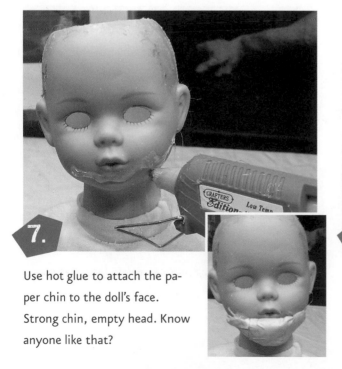

7. Use hot glue to attach the paper chin to the doll's face. Strong chin, empty head. Know anyone like that?

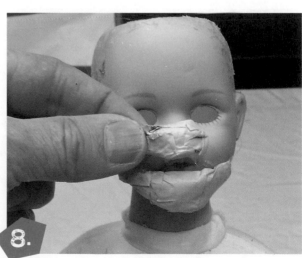

8. Add another piece to build up the nose.

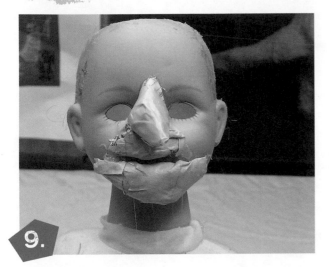

9. Maybe another. Don't worry too much about how this is going to turn out. It will definitely be scary.

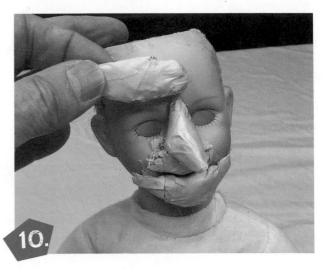

10. Make some brows and glue them to the forehead.

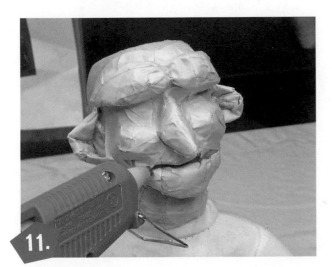

11. Add ears, cheeks, whatever looks ugly. Put some hot glue on the lip . . .

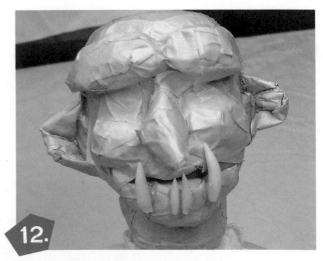

12. . . . and add bottom and top teeth. You don't need too many.

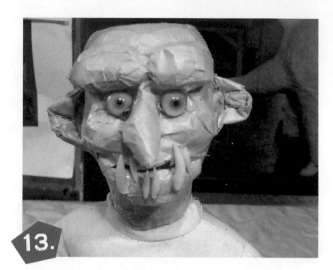

13. Use hot glue to attach eyes. I decided to use glass "bird" eyes.

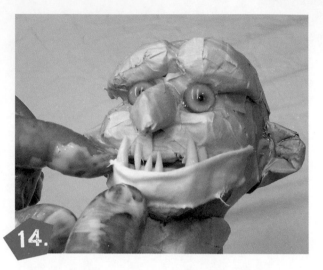

14. Time for glue and cloth strips. When you are working small, it's best to use your most worn cloth, because it will stay put. Start with a folded piece of cloth for the lips. Accentuate the fold to make Angelina Jolie lips.

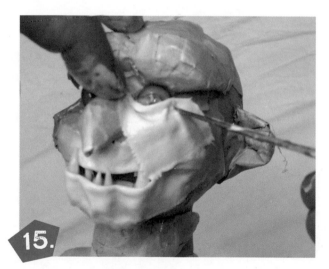

15. Fold another strip for under the eyes. Use a knife to manipulate the cloth.

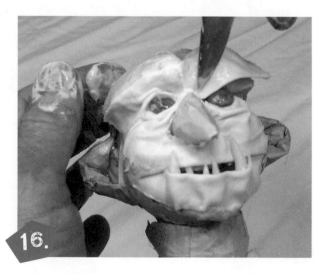

16. Fold more pieces of cloth to put over the eyes.

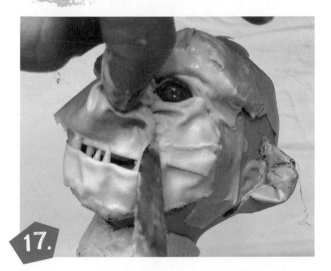

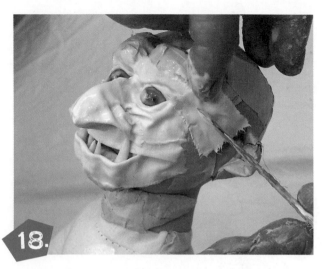

You can make nostrils by putting a large piece of cloth over the nose. Then fold the excess and pull it toward the lips. This might take a couple of tries.

Do the same to make wrinkles at the temples: Use a square piece of cloth . . .

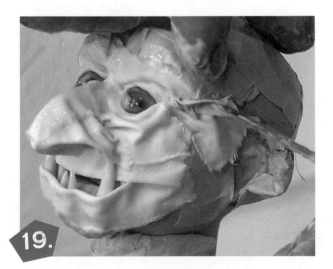

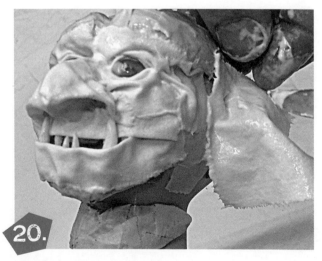

. . . and crinkle it at the corner of the eye.

Once again, do the same for the ears: Use a large piece of cloth . . .

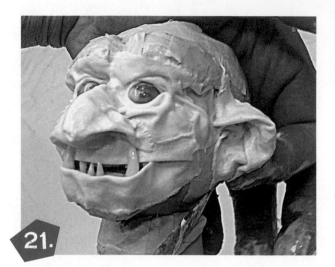

21. . . . and fold it around the edges of the paper ear. Ignore the temptation to smooth the cloth. Leave the wrinkles as they form.

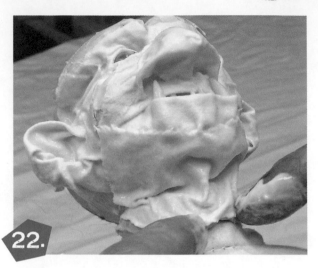

22. Use a bigger piece of cloth under the chin. Crimp the cloth for more wrinkles on the neck.

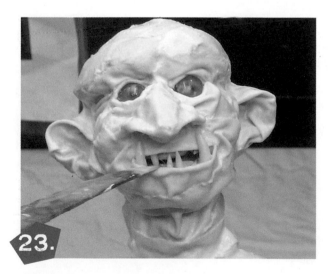

23. Use your knife to flatten loose edges and to make final adjustments on the face. I added a couple horns after painting.

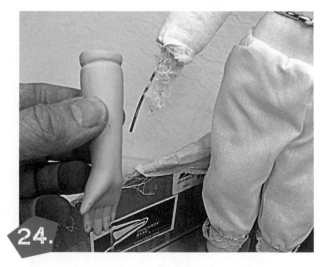

24. It was easy to remove this doll's hands. I cut the cloth and pulled them out. Later, I reattached them by squirting hot glue on the arm and pulling the cloth sleeve back over it.

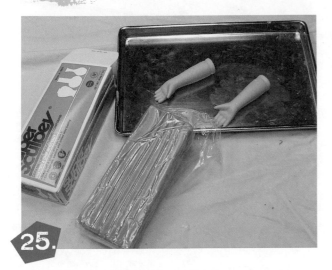

25.

This doll's face and hands were a ceramic-type plastic. I decided to make the cute hands ugly by applying Super Sculpey on them and baking them in the oven at a low temperature.

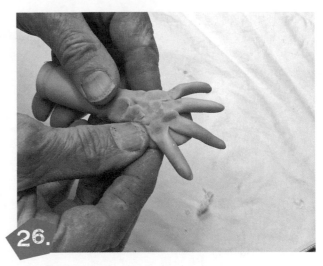

26.

I squished some Sculpey onto the arms and hands. I then attached some fingers. Finally, I pinched some wrinkles. These hands painted beautifully after baking and made a nice addition to an ugly art project.

27.

Make sure the shoelaces on those pretty red shoes are messed up. Details matter!

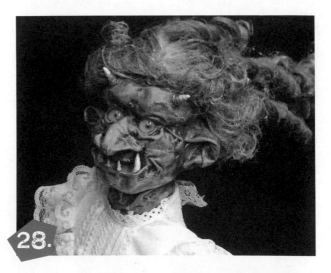

28.

Paint the face and hands. Let dry, then put the dress back on. If you want to add back the hair, first dip it into glue, hang it upside down, and let it dry. This will uglify it. Then hot glue it into place. There, a perfect makeover.

Delightful Monster Details

I'VE HEARD IT SAID that "the devil is in the details." Maybe so. But since we like monsters, that's not a bad thing, is it? In fact, for monster makers, maybe the cool devil details are in the details. Maybe the devilish monster details are in the monster's details. Maybe I should stop writing.

Thousands of people have used just the Basic Monster instructions with fantastic results. I know because they send me pictures of their monsters. I have boxes of them. I see them in my sleep. So the details I'm going to give you are completely optional. And I know that adding these details takes additional time—time you don't have unless you call in sick from work or skip school or skip your afternoon nap. And adding details takes patience—patience you don't have unless you meditate or do yoga or are just born that way. It is true, there are people in the world who are just patient. I call them "patient people." Sometimes they come across as just slow. They drive the speed limit. They probably live longer. They can't understand why we impatient people are in such a hurry. Well, let's all snatch a little time away from our busy lives and practice a little patience. Let's add some *scales* to our monsters.

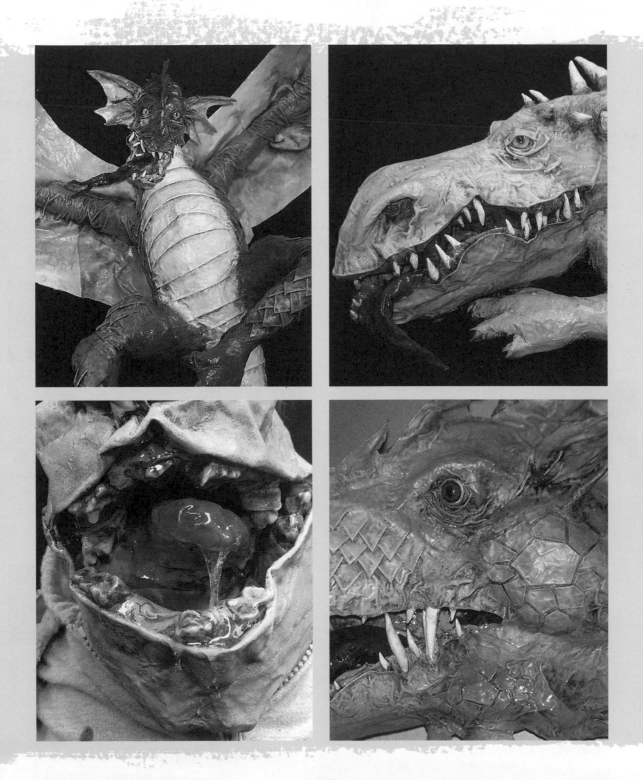

SCALES

Scales have become one of my trademarks. I put scales on lots of my art. They are so simple to make, and they add a level of detail that enhances almost any monster. They are particularly nice on monster fish. And, of course, what would a dragon be without scales? (Well, yes, probably a worm.) One of the side benefits of scales is the strength they add to the art piece. Since they are just folded pieces of cloth dipped in glue, you end up having two or three or four layers of cloth wherever you have scales. Very strong. Which is why dragons grow them. I'll show you how to make two different types of scales.

Cut a pile of small square pieces of cloth for scales. Dip one square into glue. Then fold the cloth into a point.

Place the scale somewhere on the beast. Repeat to make a row of scales.

Add the next row by putting a new scale in between the scales of the first row.

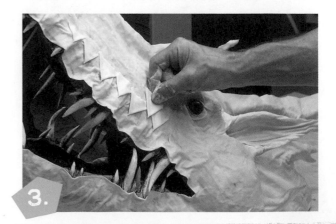

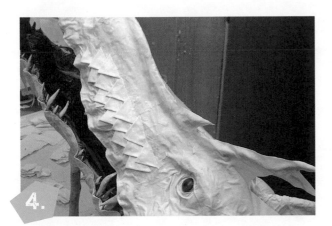

4. Continue in the same way with each successful row.

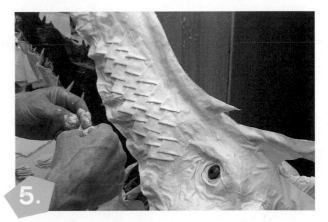

5. This is rather like a bricklayer adding bricks, each scale straddling the ones underneath. By the way, adding *patches* of scales is often as visually effective as putting scales over the entire monster.

ANOTHER KIND OF SCALE

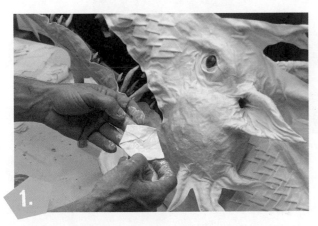

1. You will need to start with a larger piece of cloth for this kind of scale. Instead of folding it into a point, fold the cloth on all sides, making some polygonal shape.

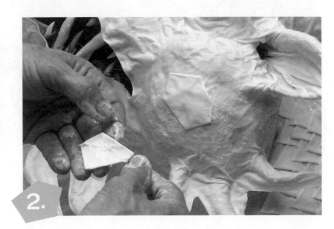

2. Fold another slightly different polygon.

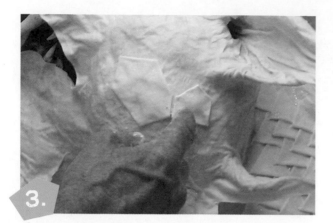

3. Match the length of a side of your new polygon with the previous one. Leave a little space between the scales.

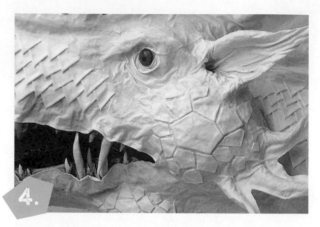

4. It can be a bit challenging, but continue to fold shapes that fit next to and in between the others. Work your way outward until you've filled the space.

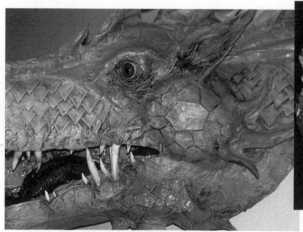

Two Kinds of Scales

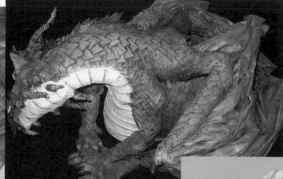

More Dragon Scales

Fish Scales

WEBBING

This is a great technique to use for dragon wings, big ears, fish tails, and other monster adornments. When you use this for wings and then paint with latex paints, you get the wonderful added benefit that they actually feel like leather. You could swear that you were touching dragon wings (just like you did when you were a kid).

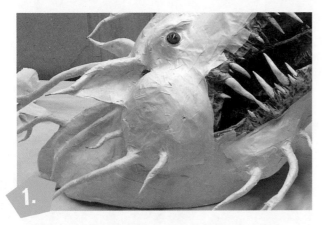

To web anything, start with spines or horns or tentacles or long fingers.

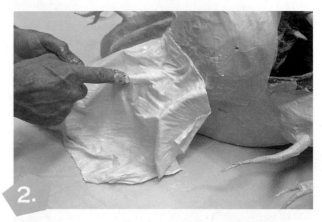

Cut a piece of cloth that is larger than the area you want to web. Soak the piece of cloth in glue and squeeze out the excess. Drape the cloth over the spines. Let the cloth dip in between the spines. If you want it to be really billowy, push the cloth deeply between the spines.

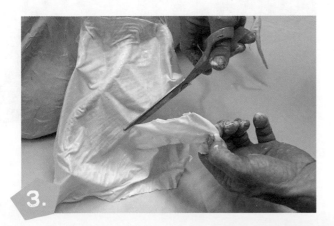

With some old scissors, cut off any excess cloth while it is still wet.

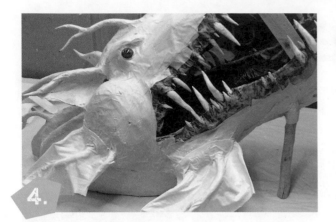

4. Let the cloth dry overnight before trimming again.

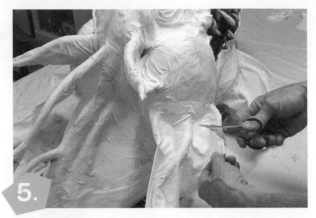

5. Use a good pair of scissors (sharp, with no glue on them) to trim the cloth when it is dry.

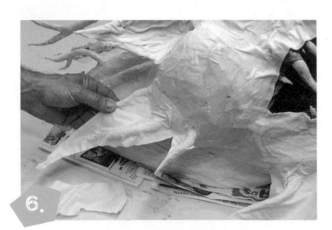

6. In this case, I cut very deeply between the spines. You will see different examples of trimming on projects throughout the book.

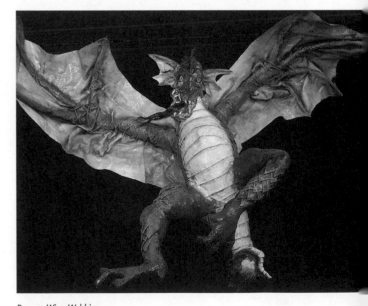

Dragon Wing Webbing

GNARLY MONSTER HANDS & FEET

For this section you will need:

- An old phone book
- Narrow masking tape
- Claws, if you want them
- Forgiveness

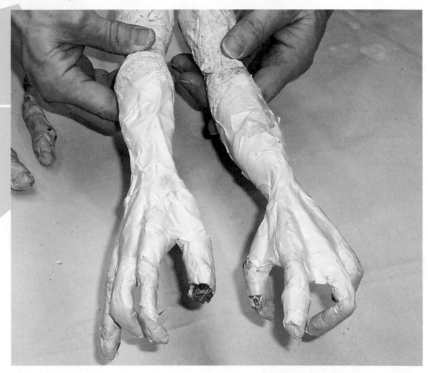

Are you dissatisfied with your monster's plain old hands? Most monsters will look just fine with regular hands and feet like the ones pictured here. But what if you want a tricked-out monster? What if your monster is going on a date and needs to look fantastic? Don't worry, a few wads of paper and some masking tape and your monster will look like a million bucks. (Note: I didn't say it would be *worth* a million bucks).

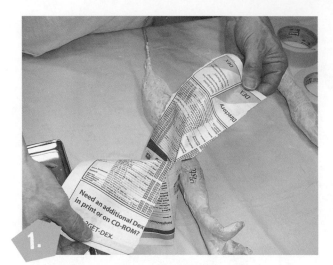

1. Once again, telephone-book paper is the ideal material for adding this kind of detail. It compresses perfectly into small balls. Tear a few half-sheets to get started.

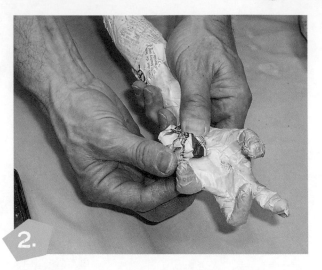

2. Start by embellishing the palms of the hands: Crumple a piece of the telephone-book paper into a tight little ball. Tape it to the inside of the hand.

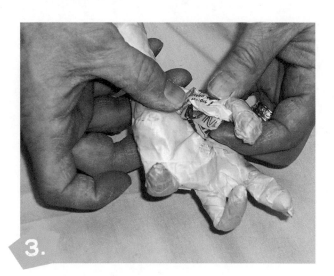

3. Put another piece under the thumb and add tape.

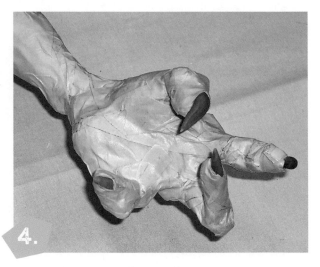

4. Add some claws at this point, if you like. Either use hot glue or just wrap masking tape around the claw and onto the finger.

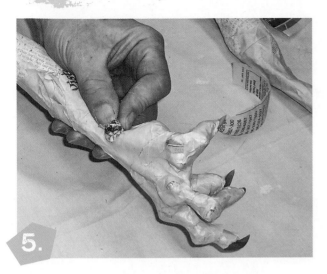

5. Make another little ball for a bone at the wrist.

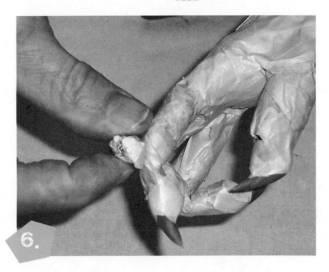

6. Similarly, add smaller balls to the fingers for knuckles.

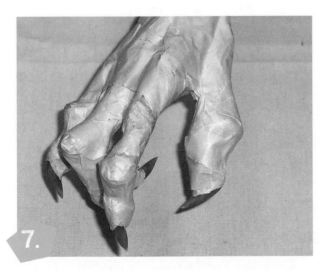

7. You can stop right here and have pretty great hands.

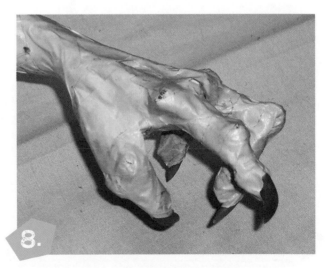

8. Or you can take it a step further by adding additional knuckles. I suppose you could continue to add lumps and bumps over the entire hand, but I think you should know when to stop. How about right here? Magnificent hands, don't you think?

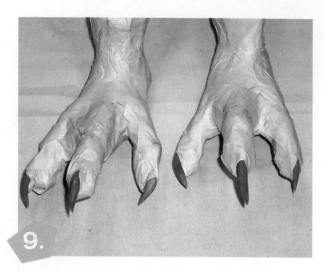

9.

Of course, now the feet look kind of plain. A little embellishment would help them as well. I suppose that's why people who get manicures also end up getting pedicures.

10.

Add a few balls just like you did with the hands.

11.

Put as many knuckle-like balls as you like onto the foot.

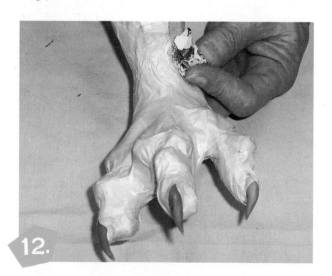

12.

Maybe even add some ankles.

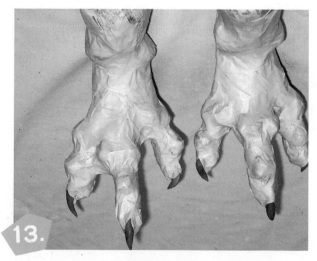

13.

Perhaps these feet became a bit too gnarly. You can always remove lumps and bumps as well as add them. Yes, like that pedicure. You decide. Either way, you'll have great-looking monster feet.

HAIR & TENTACLES

What would monsters be without tentacles? You're right—bald! Tentacles are the equivalent of monster hair. Such little items can make a big difference to your monster. There is not much to explain here. You make a tentacle the same way you make a finger or toe, except that you twist less paper around the piece of hanger and you try to taper the end to a point. In fact, if you want a sharp point, don't have any paper around the wire at the end, just tape.

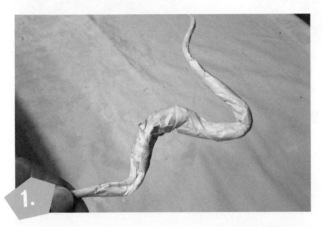

1. After twisting the paper and taping, bend the tentacles into various shapes.

2. I use lots of different sizes and shapes of tentacles for most monsters. These are the tentacles I used for the Marionette (page 72).

3.

To make life easier later, wrap the tentacles with cloth-mâché strips *before* putting them on a monster. Stick the ends into an extra papier-mâché ball for drying.

DROOL

- Clear fiberglass casting resin
- Catalyst for the casting resin (it usually comes with the resin)
- A glass jar for mixing
- An old paintbrush (expect to throw it away afterwards)
- Safety glasses and latex or rubber gloves[1]
- Newspaper or cardboard to catch the drips
- A big ego

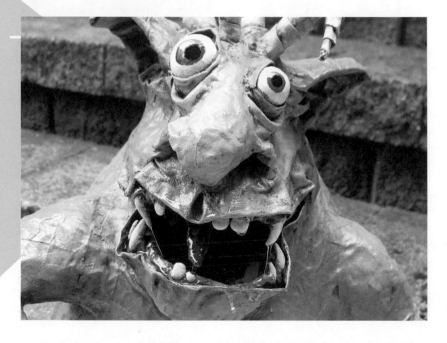

Drool is cool. Maybe not if you are half asleep, sitting at your desk at work or in the front row of the classroom at school, and it starts flowing. But in the monster world, drool is definitely cool. **Please note: This detail is not for the faint of heart—or for kids. It's potentially very dangerous if you use the materials I suggest. If you decide to go ahead, it should be done by a competent *adult*, preferably a non-smoker.**

A very important note about the supplies: You can buy **clear fiberglass casting resin** at some craft stores. Sometimes you can get it at hardware stores. Make sure that it is "clear" casting resin. I bought mine at a plastic store (I mean, they sell plastic, not that the store is plastic). Note that you can make drool with materials that are less toxic, like clear caulk. It's a lot safer but doesn't look nearly as droolish. The **catalyst for the cast-** **ing resin** is actually much more dangerous than the resin. If you get it in your eyes, you can do great damage. **DO NOT** do this unless you have safety glasses and gloves. You should also do it outside. **DO NOT** do it indoors. The fumes are strong and flammable. I repeat, **DO NOT** do it in the house. If you have a pilot light going for your furnace or water heater, you could **blow up** your house. Yes, you read that right!

[1] Make sure to read the "very important note about the supplies" above.

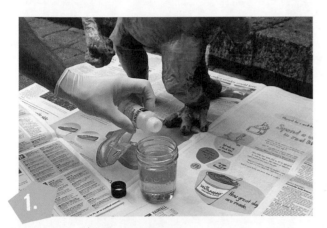

1. Pour some casting resin into the glass jar. Add two or three times the recommended amount of catalyst. I just kind of squirt a bunch in there. Stir until it is thoroughly mixed. The color will actually change a little. Note my safety gloves. I'm wearing safety glasses too.

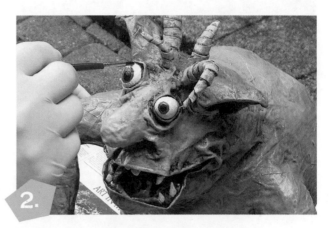

2. If you used clay eyes that you painted, a coat of casting resin will make them look very eye-like. Paint the resin onto the eyes first while the resin is still fluid.

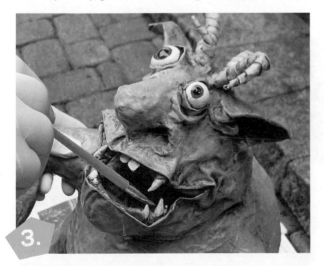

3. Also paint the mouth with the resin before the resin starts to congeal. Usually, you have about 10 minutes before the mixture starts to get thick and gooey.

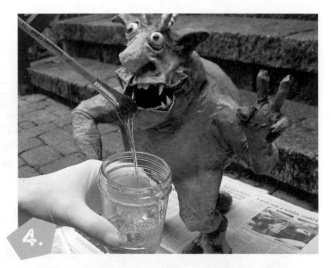

4. This is the most important part of the process: Stir the resin slowly. After about 5 minutes you'll notice substantial thickening. The catalyst has accelerated the hardening of the plastic. The trick is knowing exactly when to add more resin to the tongue and teeth.

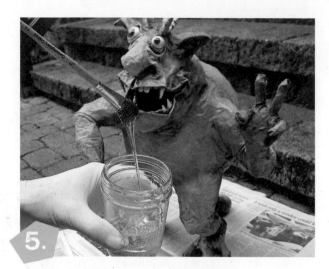

5.

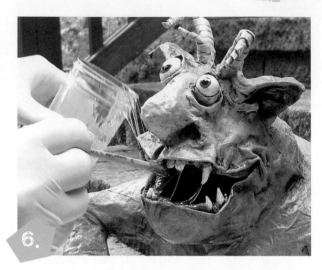

6.

As soon as you notice that the resin is running off the brush slowly, start painting it onto the teeth, tongue, and lips. *You must work fast.* You will only have about *10 seconds* to work before the resin becomes too thick to apply.

There is an element of luck here. Some drool will slowly drip off. And some will pull back into wonderful long drips.

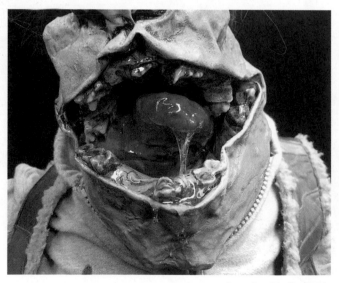

Examples of Perfect Drool

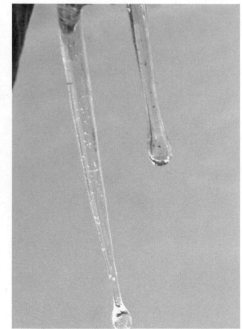

118

MORE ABOUT JAWS & TONGUES

Making jaws is an art all by itself. You should make a few to have around the house just in case you need them (see p. 41). Having a bunch of jaws around is like Leonardo da Vinci having a bunch of sketches around (except that you aren't a famous artist and mouths aren't like drawings).

I promised to share with you all of my accumulated knowledge about my own papier- and cloth-mâché methods. I'm sure that some of this will appear to be much ado about nothing. I would argue that the difference between my work and that of a novice boils down to relatively small, subtle things. Like how I place teeth into some of my jaws. So, in the interest of complete artistic disclosure, here are some additional hints that can improve the quality of your work. Of course, feel free to ignore all of this if you have already developed methods that work for you.

A Sidebar about Teeth

I've used many things to make teeth and claws. I've used regular clay that I fired in a kiln. I've made molds that I poured melted plastic into. I've used low-melt plastic. I've even carved teeth out of wood, like someone did for George Washington. I've decided that the best material for making teeth and claws is some sort of oven bake plasticene clay. Super Sculpey works pretty well, but I think, overall, Fimo is the product I prefer. It comes in many colors, it's easy to mold, and it doesn't

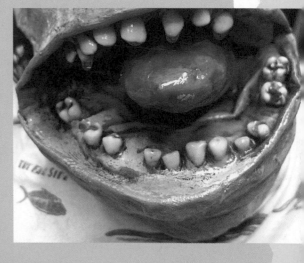

smell too bad. And if you paint over it with latex paint you can peel the paint off later. So if you use tooth-colored Fimo to begin with, you don't have to worry about getting paint on the teeth. Just peel it off afterwards. (I did not get paid to say this about Fimo.

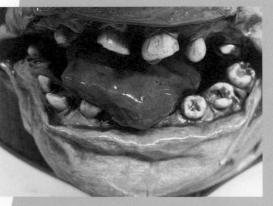

Although, if Super Sculpey sends me a big check, I might change my mind about the "best" material.) Of course, if you can get them, human or animal teeth make the best teeth. Know any dentists? I do.

I know—these are kind of gross. In fact, the jaw on the left also has some cow teeth that my meat-cutter brother got for me (it's a long story).

119

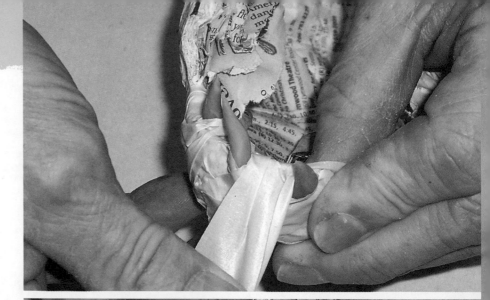

As you've seen, I use hot glue to put teeth onto jaws initially. This is only meant to hold the teeth until they are wrapped with cloth strips. Hot glue alone isn't sufficient to hold the teeth permanently. Often I will use masking tape to put the teeth onto the jaw. Masking tape is actually sufficient to hold the teeth forever, especially if you paint afterwards. Stretch pieces of tape on either side of each tooth. As always, pull on the tape to achieve tension.

If you do this right, you might not even need the cloth-mâché inside the mouth. Just make sure that you've added enough tape to cover the inside of the mouth completely and then paint.

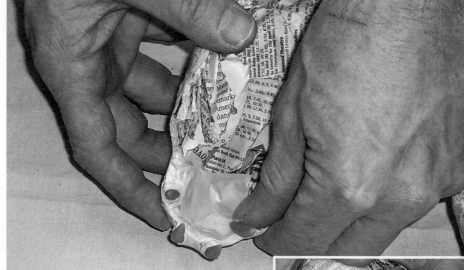

You can get a really nice effect by alternating the placement of teeth, one *inside* the jaw and the next *outside*. This is very much like an alligator's jaw.

And it's worth reiterating that placing teeth on one side of the jaw opposite a gap on the other will provide for an excellent full mouth of

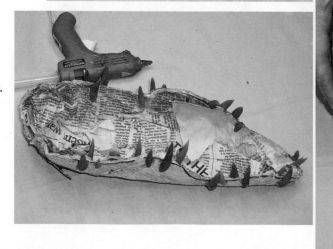

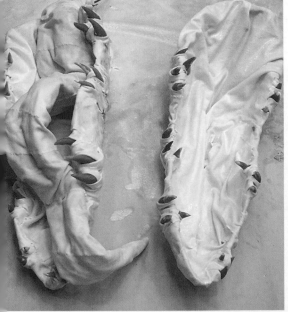

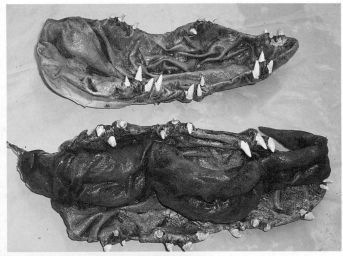

teeth. The fact is, if you fill a jaw completely with teeth, it will look very overcrowded (although that's okay if that is the look you want).

Of course, long jaws require long tongues. Cloth-mâché the tongue and jaws at the same time so that they stick together.

Paint the teeth (or peel the paint off the teeth if you used tooth-colored Fimo) and black-wash. Recall that detailed steps for making jaws are in the "Jaws and Claws" section of Basic Monster making.

Put the jaws into some cool beast!

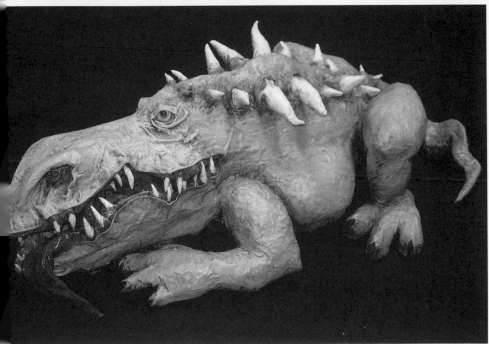

Some Cool Beast

More Monsters

THE TITLE OF THIS SECTION might be misleading, although no more so than the rest of the book. There are obviously pieces of art in the book that are not "technically" monsters. I mean, a piggy is probably not a monster, unless it's trying to eat you (I've heard that some try). And this final group of monsters will have a couple non-monsters in it. I'm not completely sure if a vampire or a creepy pumpkin are "monsters." I suppose someone has a lawyer on this right now.

The point of this last section is to give you something to look at now that you've had some experience with papier- and cloth-mâché techniques. Once you've made a project or two, you will see the features of this gallery in a new way. You'll recognize subtle variations of the techniques and feel confident applying them in your own future work. Hopefully these art pieces will spur some creativity and a desire to make some additional art pieces. So take a look around—and good luck on your next project!

Let's start with a few simple monster variations.

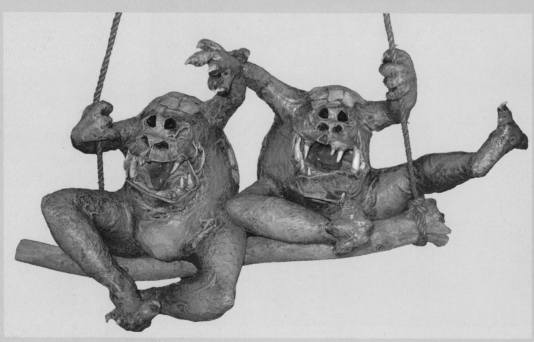

(Above) Twins; (Opposite page from top, clockwise): A Simple Screamer, Tongue Tied, Screamer on a Rope, Downward Facing Doug.

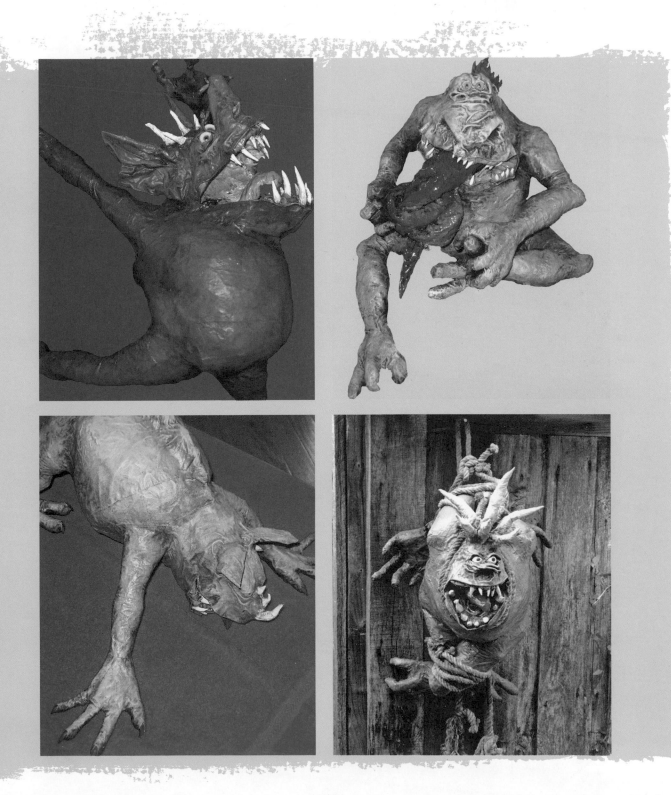

Even though you are a monster maker, I think at some point you'll need to make a fish or two.

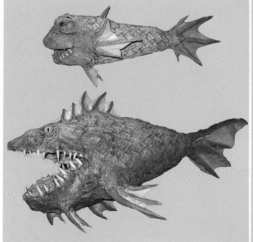

A Little Fish and A Medium Fish

As you can tell, I like to make things eating other things. (You have to look really closely to see what the bug on the opposite page is eating.)

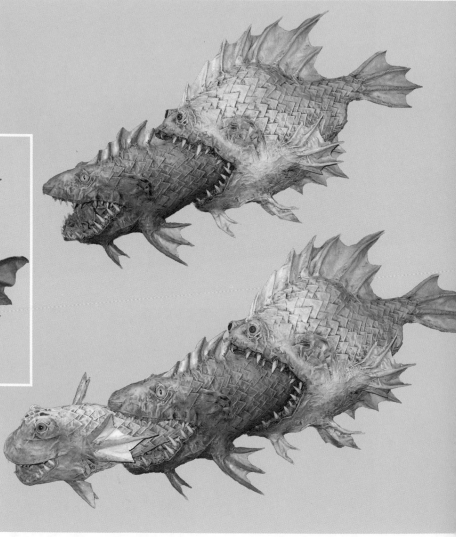

Big Fish and Half a Medium Fish and a Fishwichwich

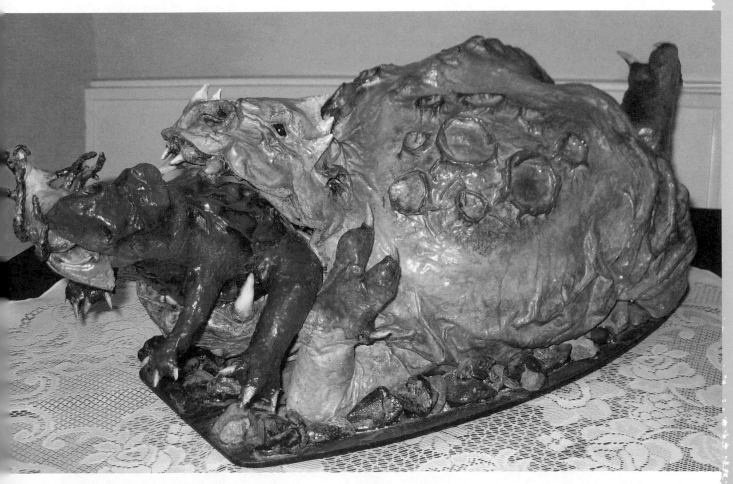

Four Basic Food Groups

Polly Got a Squawker

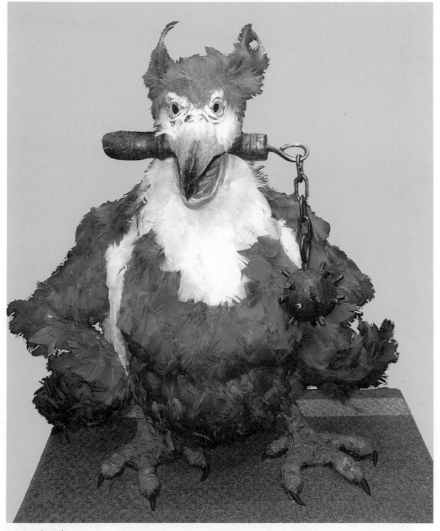

One Tough Bird

Birds are nice too. I didn't put "Adding Feathers" as a detail, mostly because they are so much hassle. They fly everywhere. They stick to your glue gun. Pieces of them float into every orifice of your body. Still, if you are determined, you can make a nice bird using feathers purchased at craft stores. Use hot glue to put them on. Start low and work up, covering the top of each previous feather as you go. Good luck! (Don't do it!)

As you were looking at the birds, you might have noticed the props. Here is a special extra hint just for you. If you draw a blank when thinking about your next project, I suggest you take a trip to the secondhand store. Aside from getting old sheets and excellent cute dolls to ruin, you'll undoubtedly find all kinds of interesting trinkets guaranteed to inspire. Kid's clothes are the perfect size for monsters. You saw some thrift store clothes on the marionette. With thrift store kids' shoes comes the special treat of not having to make toes. Just stick the little shoes on the end of your monster's legs. Don't want to cloth-mâché the body? Pull a sweatshirt over it.

The Tough Bird got a flail. Yes, I found a flail at a thrift shop! I can hardly wait to stick something in the meat grinder I found. I also found a great bird cage . . .

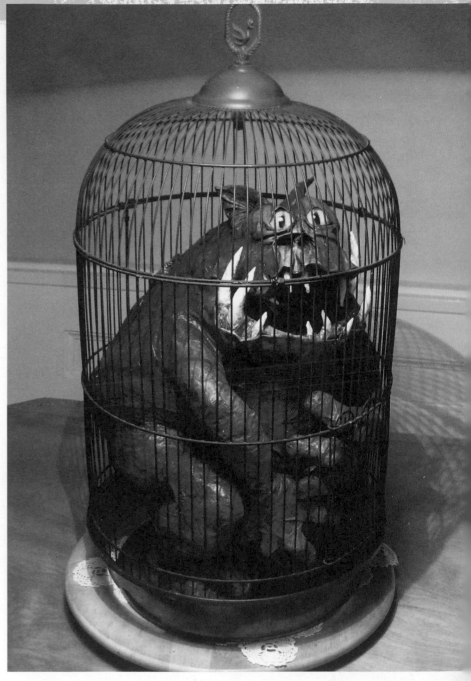

Bye Bye Birdie

. . . and a cool kid's leather vest. And a wig.

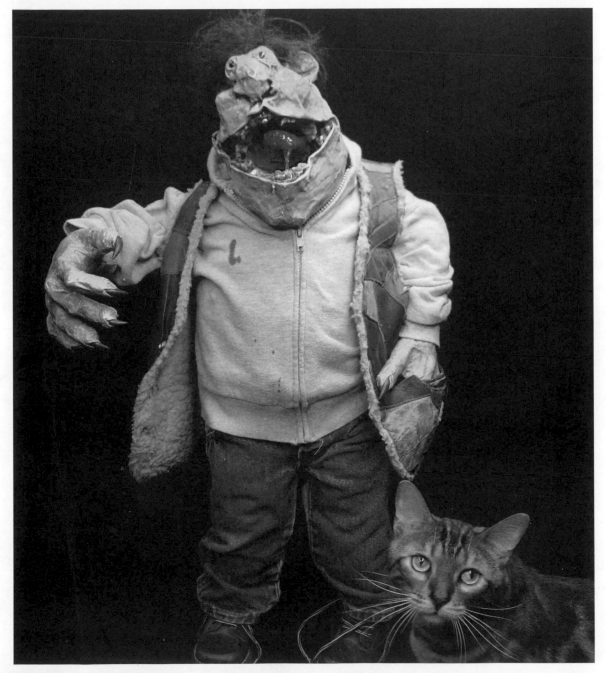

Ned and Max

While I'm on the subject of secondhand stuff, I'm one of those people who can't walk by a garage sale without seeing if there is something to use for art. Recently, I found this really terrific little samurai outfit. I don't know what it was used for before I got to it, but I realized that all I needed was a little monster person to fill it up.

Samurai Suit + Naked Little Monster

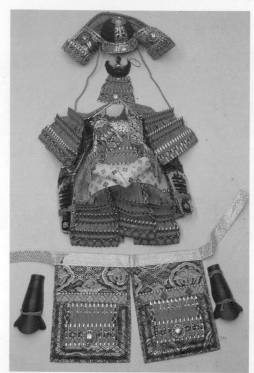

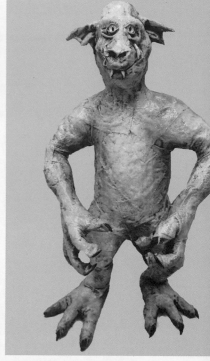

Monster Samurai

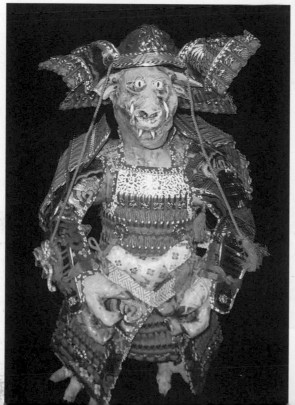

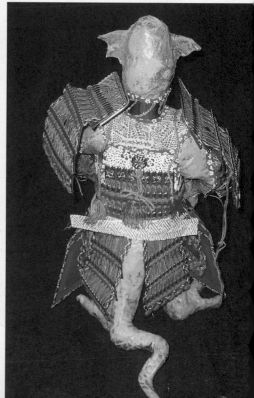

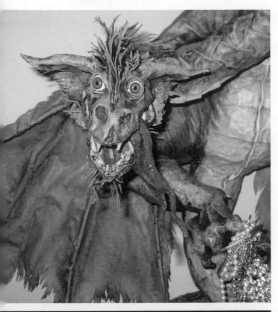

In the end, may I suggest that you make a dragon. Dragons are not quite monsters, although I think that a dragon could beat a monster in a fair fight. On the monster meter, you'll find dragons at the way cool end. I have them all over the house. You've seen the one in my bathroom. The one on the left hangs over my bed. Where are you going to put yours?

Here are a few of my other dragon favorites.

Clockwise, from top right: The Two Sides of William, Sky Dragon, Sea Dragon

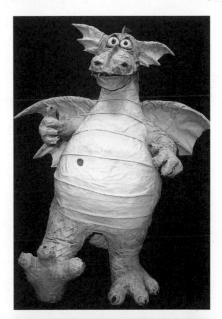

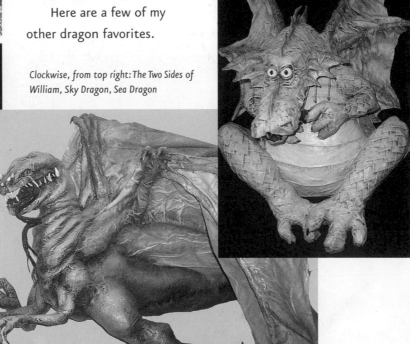

As you've seen, I've spent a fair amount of time observing cat behavior, especially around papier-mâché. For reasons that only cat lovers and dragon artists (and maybe crazy people) will understand, I've come to the conclusion that cats and dragons have a lot in common. So it seemed only fitting to make a few catlike dragons. I started by making a couple kitten-like baby dragonlets.

Of course, baby kitten-like dragons need a mother doing something cat-like.

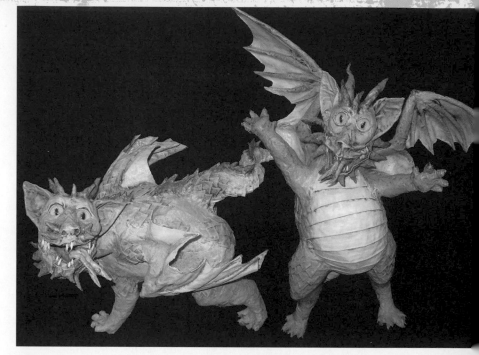

"Kittens"

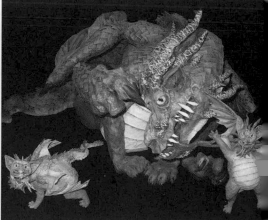

A Little Dragon Pride

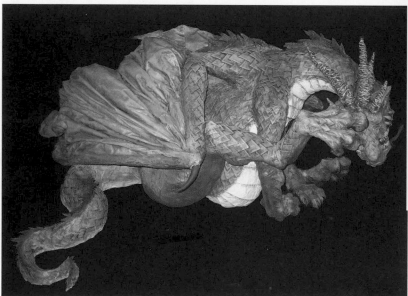

Mother Dragon Scratching Her Eye

After deciding to add a Halloween section to this book, I made another trip to the thrift shop. I picked up two more jackets, one pink and black and one black velvet. You'll see how I used these and two of the wigs from my previous trip in my . . .

Special Halloween Section

For people who write and buy monster books, monsters have no season. For people like us, monster love extends throughout the year. But our ranks grow for a few days at the end of every October. Many people who would never consider making a monster in July find themselves considering it right before Halloween. I'd be remiss as a monster artist if I didn't include a section on basic Halloween art. "Basic" means a couple heads to look out the window (ideally into your neighbor's house), a cute little bat to hang above the porch or on the wall in the baby's room, and, of course, a pumpkin—one on the creepy side.

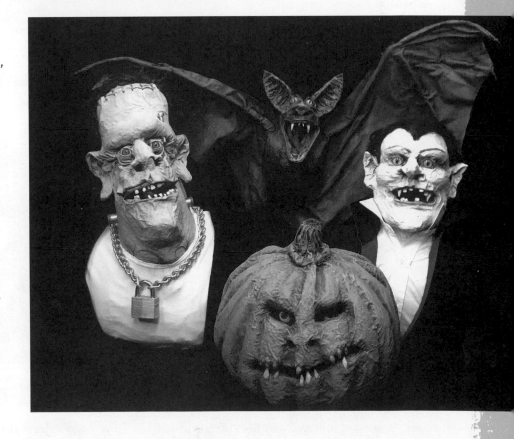

BUSTS

Remember, these instructions are meant to augment and extend the other instructions in the book. Before you cloth-mâché or paint, review the appropriate sections of "Basic Monster" making.

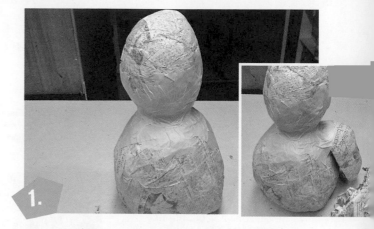

1.

Start with a stack of mâché balls. Most sizes will work. Cut up other balls to make shoulders.

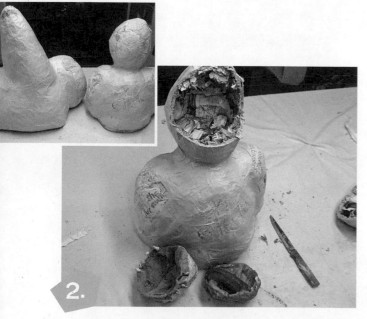

2.

Add pieces to the base if you want . . . or not. As I've said throughout the book, don't worry about these shapes. Everything will work out fine. Let the project surprise you. Cut a hole in the face for the jaws.

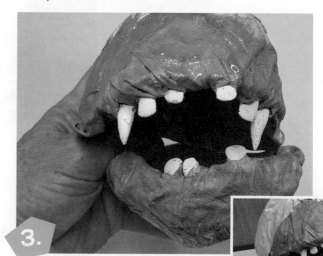

3.

Since one of these heads will be a vampire, I made the canines longer and pointed. Put the jaws into the hole and tape. Use another piece of a mâché ball to make a chin.

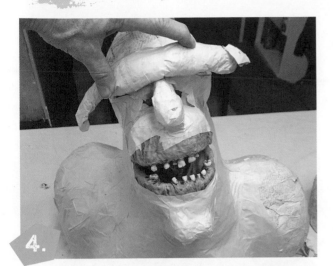

4. Use any "nose shaped" balls for a nose. Sometimes I twist a piece of newspaper and wrap it with tape to make features. In this case it's a heavy brow.

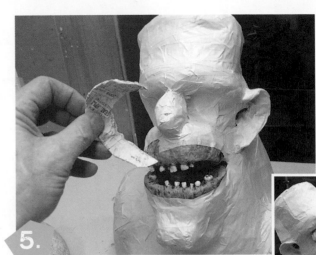

5. Fashion ears and nostrils out of excess mâché pieces. Add some eyes and then cloth-mâché. For Frank's famous split forehead, I folded a long piece of cloth and put it above the forehead.

Q: I've heard that it looks better to have four fingers on a monster's hand than five. Is this true?
A: Yes. Unfortunately, it forces monsters to use base 8 when they count.

Q: Are there any other problems with using four fingers?
A: Well, they have to give each other "high fours" when they win at basketball.

Q: With so many problems with four fingers, why don't you just use five fingers instead?
A: When teaching teenagers how to make monsters it's best not to have middle fingers.

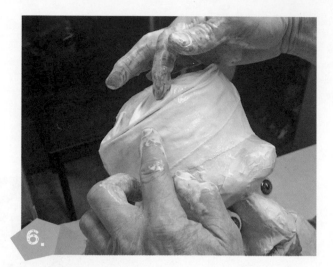

6.

I then put another piece on the top of the head. I used metal electrical staples for the "stitching." Add some nice accessories—a bolt here, a bar there. Perhaps a nice chain necklace. Again, look for old wigs and clothes at a local thrift store. Cut them up and hot glue them in place.

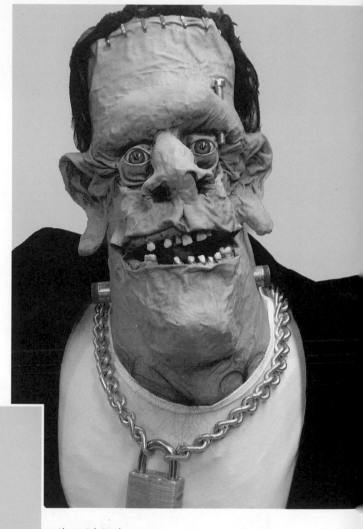

Above: Fab Frank
Left: Dapper Dracula

A CUTE LITTLE BAT

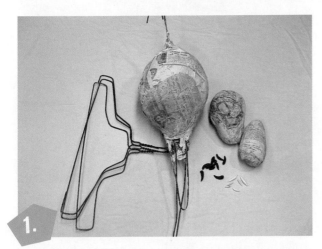

1.

Use a body with hangers inside for this project (review "About Wire Clothes Hangers"). You will also want some extra hangers and a couple small balls for the jaws and appendages.

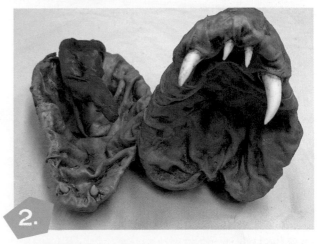

2.

Like the vampire in the previous section, I made jaws with long, pointed fangs.

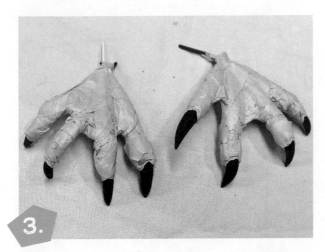

3.

Make some cute little feet.

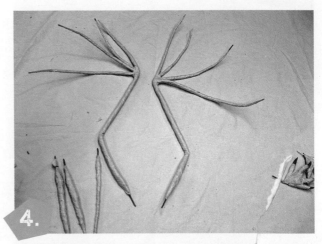

4.

Tightly twist paper around hangers and wrap with tape. Tape these together to form a structure for the wings. Use smaller pieces for a tail and the bat's skinny legs.

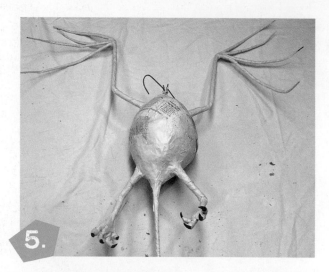

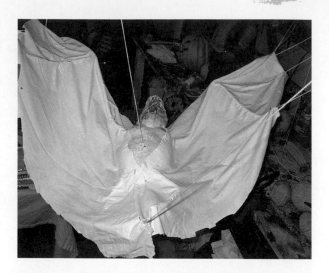

5. Assemble the bat's body. Poke the wings, legs, and tail into the body and tape. Cut a hole in the top of the body (you will need to cut out pieces of the hanger) and put in the jaws. These wings are large and require a variation of the webbing techniques I showed you earlier. I taped strings to the ends of the "fingers." I also exposed part of the hanger inside the body and tied a string to it. I used these strings to hang the little guy from the ceiling. Dip the cloth in glue and drape it over the wings.

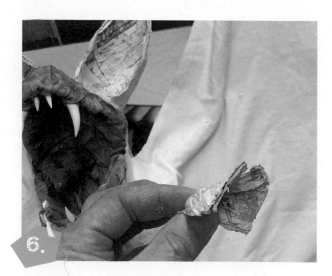

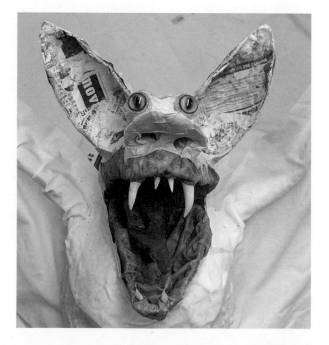

6. Trim the wings when they are dry. Again, use pieces of smaller mâché balls to make ears and a nose. Add eyes. Finish the cloth-mâché on the face, the back, and the rest of the body.

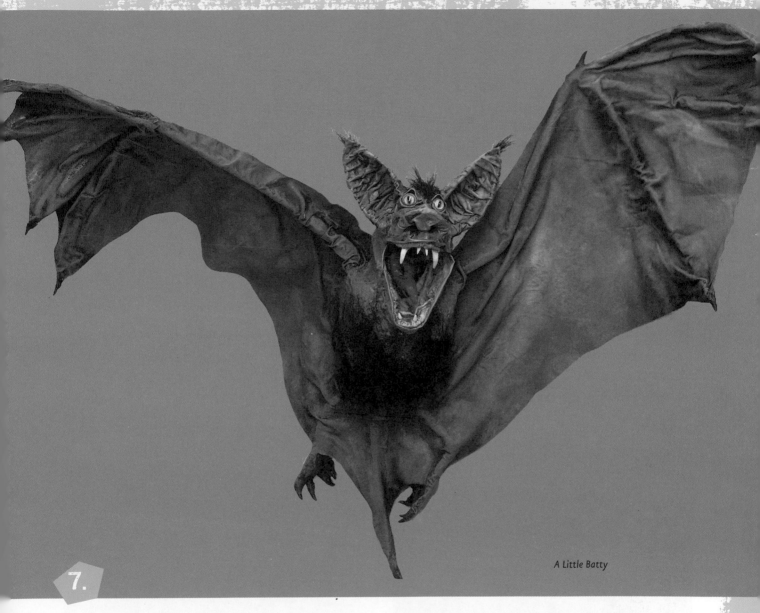

A Little Batty

7.

Paint with latex paints. I used primarily black. While it was still wet, I splashed on some brown. (Well, actually, I used yellow, blue, and red to make the brown.) I wanted a few tufts of hair on the bat, so after the paint was dry, I smeared white glue on the belly, behind the ears, and on the top of the head. I then cut some hair off an old wig and pressed it onto the glue. Since there are hangers in the body, expose a part of one on the back. Tie a string to it for hanging. Or punch a hole in the back and hang it on a screw in the wall.

PUMPKIN

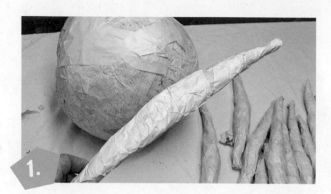

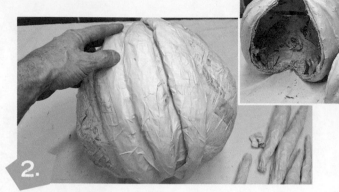

1. Start with a papier-mâché ball. Twist a sheet of newspaper. Twist tighter at the ends to create a taper. Wrap this in wide tape. Make a pile of these (how many you make depends upon the size of your pumpkin.)

2. Tape these pieces all the way around the ball. Cut open the back and pull out the paper wad.

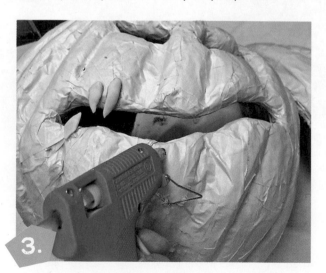

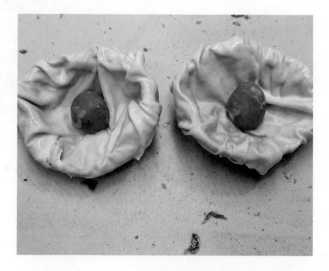

3. Cut out a mouth and eyes just like you would any normal pumpkin. Wrap the holes with tape. Hot glue some teeth onto the pumpkin if you like. For a great effect, make some eyes to put into the eye sockets. Use

the half shells of a small mâché ball. Dip cloth in glue and fill the sockets. Leave the wrinkles, of course. Put eyeballs into the middle. Paint the sockets and eyes after they are dry.

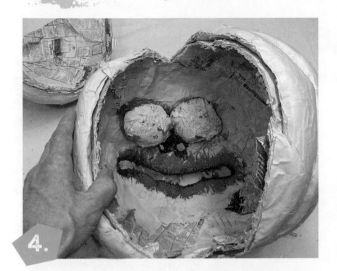

4. I put cloth around the teeth and painted part of the face while the pumpkin was open. Hot glue the two eye sockets to the inside of the pumpkin. Tape the pumpkin back together. For a stem, cut off the ends of another small mâché ball and tape it to the top. Add small wads of tape around the stem.

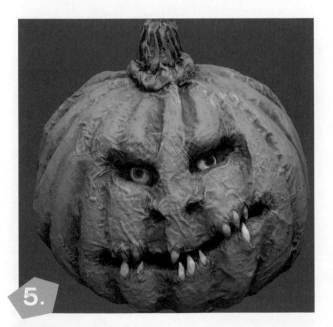

5.

A Slightly Creepy Pumpkin

Cloth-mâché as you would any other monster. Note that I wrinkled the cloth as I wrapped it around the stem. I noticed that the eyes are not always visible from every angle. This adds an eerie touch to the traditional Halloween pumpkin. Of course, if you don't want to scare the kids, have them close their eyes.

About the Author

I've been making papier- and cloth-mâché sculpture for many years. I made my first monster with my fifth-grade students in 1972. I required that they make monsters so that their success would be guaranteed. After all, no one can say, "Hey, that horn is in the wrong place!" I also told my students that painting inside mouths would be much easier if their monsters' mouths were open wide. My students noticed that our monsters all appeared to be screaming, and these monsters came to be known as "screamers." Hence the title of my first book, *The Simple Screamer: A Guide to the Art of Papier and Cloth Mâché.* And since we only made monsters, our motto became, "Make something ugly, for a change," which inspired my sequel book, *Make Something Ugly for a Change: The Definitive Guide to Papier and Cloth Mâché.*

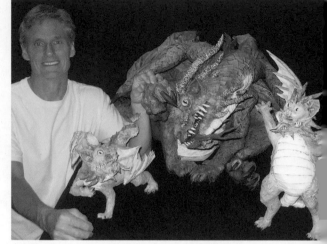

Dan with his Dragons

My motto has become simpler after all these years. Nowadays it's just, "Make art!" It'll make the world a better place.

Visit me at www.PaperMacheMonsters.com.

Acknowledgments

I just have to thank Julie, who spent countless hours taking pictures of my hands and countless more standing around while I did "just one more thing" beforehand.

And I must also thank Allison and Andrea for all of their help. If you saw my last book, you will recognize this photo of my little girls "chewing paper" to make papier-mâché for dad. Despite being older and wiser, they are still very helpful. When I needed a batch of papier-mâché balls for this book, they were right there. And it only cost me a handful of cash and the car for the weekend.

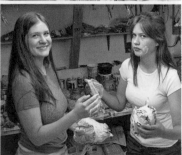

Index